B & W Photo-Lab

Processing and Printing

RotoVision

A RotoVision Book
Published and distributed by RotoVision SA
Rue Du Bugnon 7
CH–1299 Crans-Près-Céligny
Switzerland

RotoVision SA, Sales & Production Office
Sheridan House, 112/116A Western Road
Hove, East Sussex BN3 1DD, UK

Tel: +44 (0) 1273 72 72 68
Fax: +44 (0) 1273 72 72 69

ISBN 2-88046-427-7

10 9 8 7 6 5 4 3 2 1

Book Design: Saskia Gartzen & Matthew Wheatcroft – The Attik, London

Production and separations in Singapore
by ProVision Pte. Ltd.

Tel: +65 334 7720
Fax: +65 334 7721

B & W Photo-Lab
Processing and Printing

Contents

8 Gallery

16 Section 1 - Equipment

18 The Darkroom
20 Equipping the Darkroom
22 Processing Equipment
24 Print Processing Basics
26 Enlargers
28 Format Options and Negative Carriers

30 Section 2 - Films and Developers

32 Film Types
34 Developers

40 Section 3 - Processing Film

42 Development Chart
44 Processing Guide
48 Achieving a Good Negative

50 Section 4 - Processing Paper

52 Paper Types and Developers
56 Making a Test Strip and Contact Print
58 Making a Print
60 Adjusting Exposure
62 Adjusting Contrast

66 Section 5 - Dodging and Burning in

84 Section 6 - Practical Techniques

86 Tony Worobiec
94 Dave Butcher
102 Sid Reynolds
108 Michael Milton

116 Section 7 - Finishing Touches

118 Creating Borders
122 Toning
124 Storage and Presentation

126 Glossary

Gallery

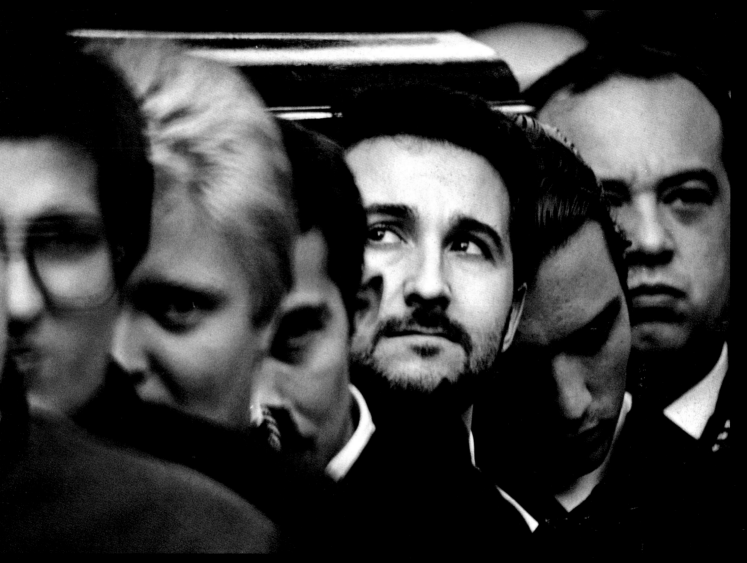

Dave Waterman **Spanish Pallbearers**

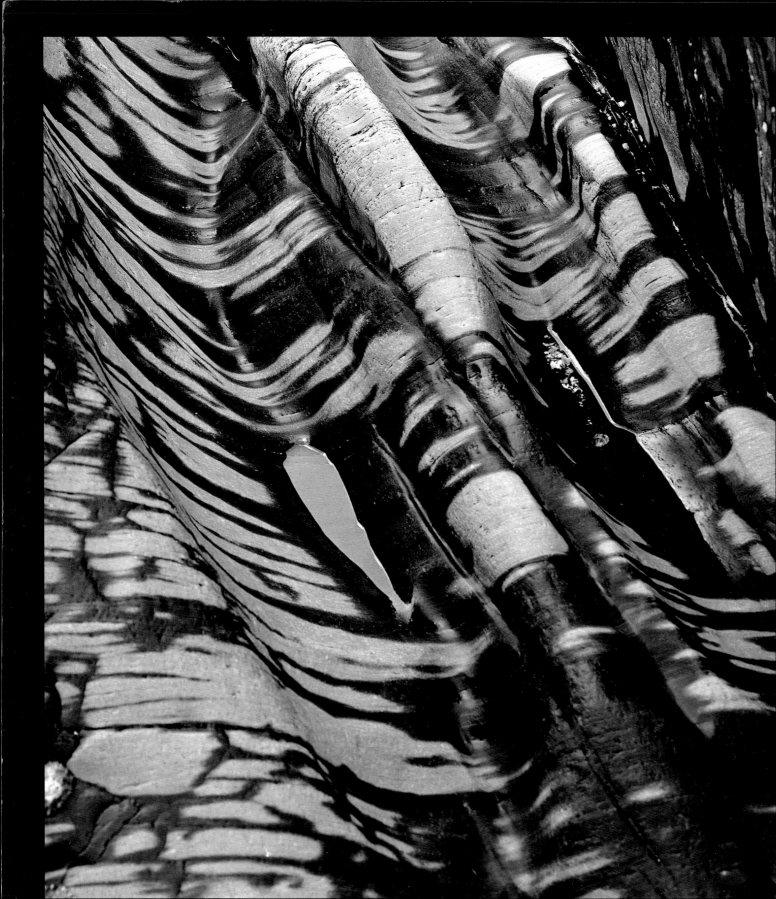

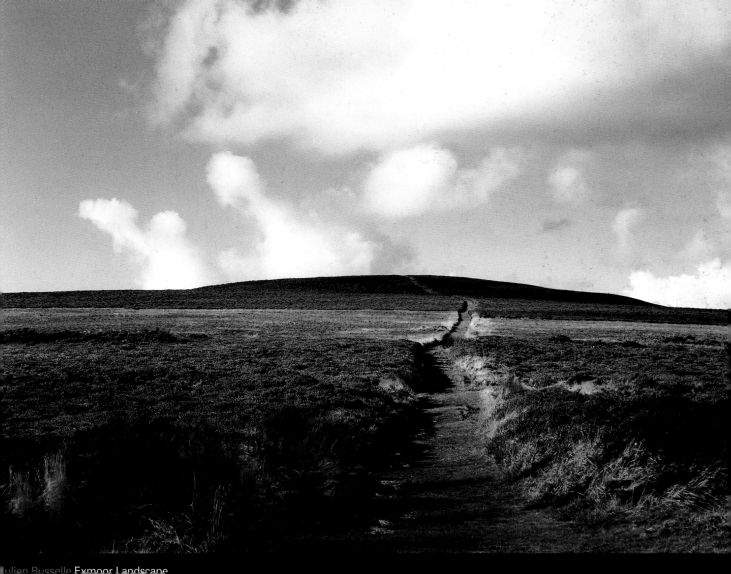

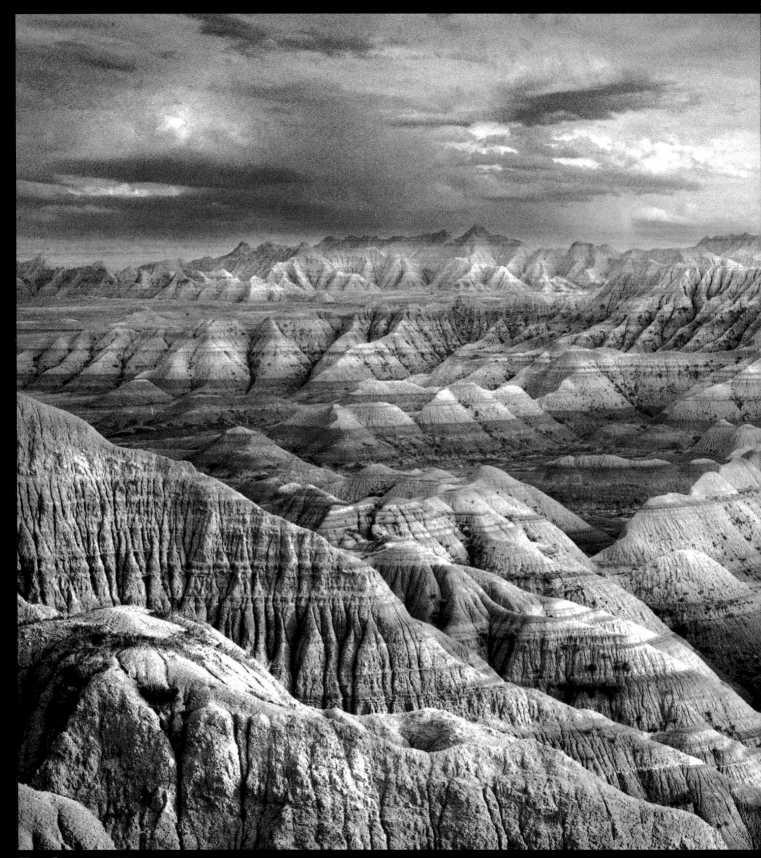

Ref. pg 75

Tony Worobiec The Badlands

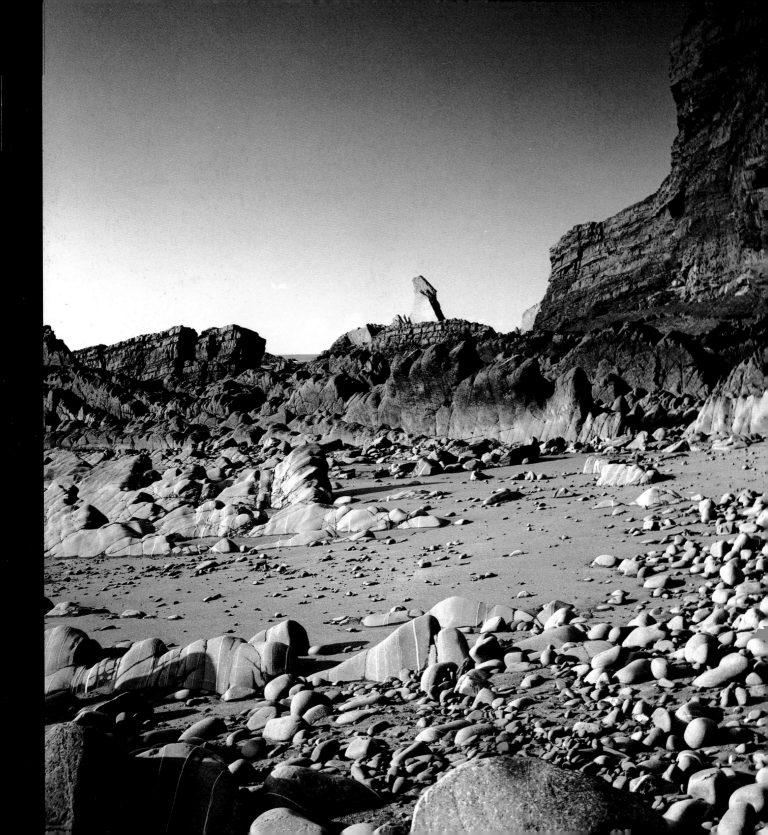

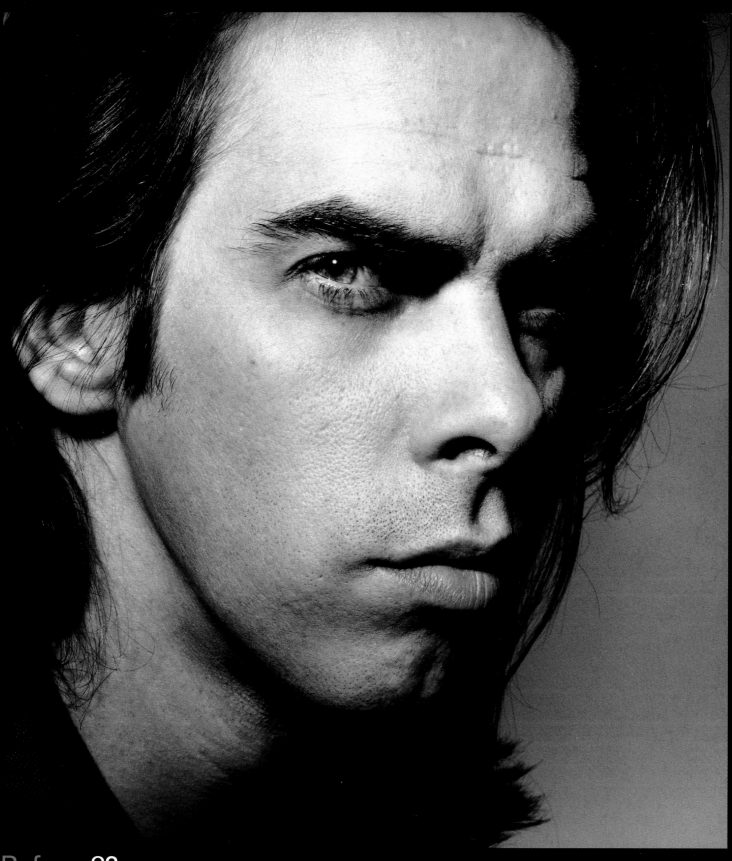

Ref. pg 82
Matt Anker Nick Cave

Equipment

Whether starting your darkroom from scratch, undertaking improvements or upgrading, it is vital to get as many of the factors right as possible. A darkroom that is clean and comfortable with efficient equipment is more likely to be used on a regular basis. As an addition to a studio or in the home a well-planned facility is one of the key ingredients for success.

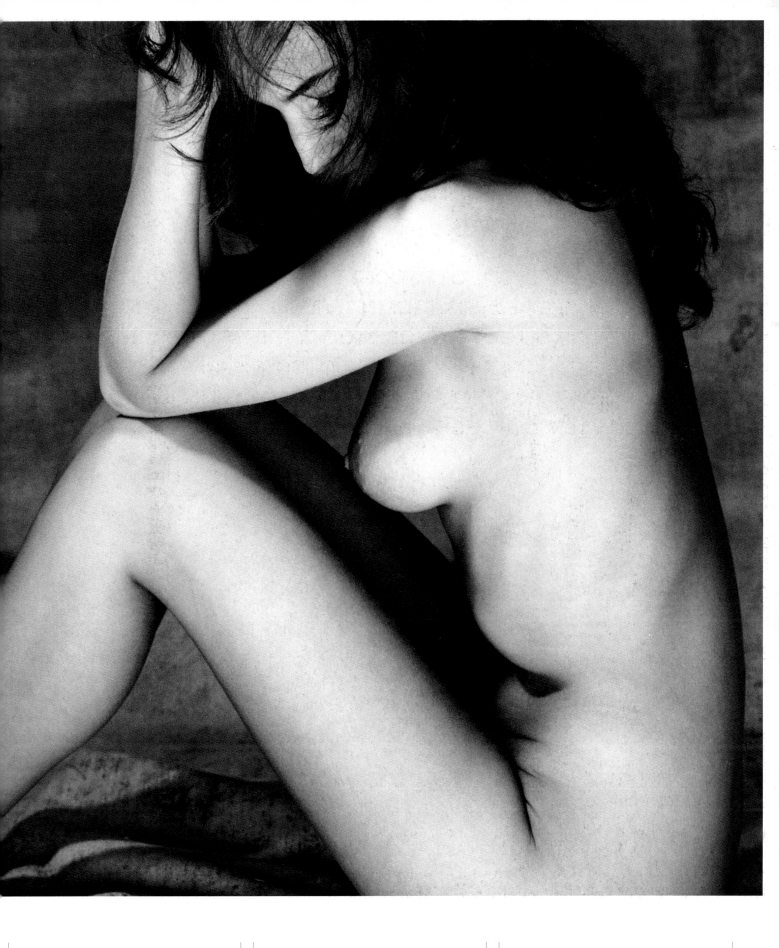

The Darkroom

The Home Darkroom

Professionals know only too well the problems associated with a makeshift darkroom, which often may simply be a bathroom pressed into use. As long as you have a light-tight environment to work in and space to put the enlarger and developing trays you can – in theory – have a darkroom anywhere. However, as equipment grows and work load with it the only sensible solution becomes a permanent set up. A spare room, garage, cellar, loft or shed can often be adapted to provide an ideal base from which to work.

Darkroom layout

Wherever your chosen site, it is sensible to separate the darkroom into a wet and a dry area, enlarger on one side, sink on the other and a clear space in between. The floor area should be bare floorboards, concrete or vinyl – carpets are unsuitable because, they hold dust and absorb spills. Safety should be paramount; electric's properly installed and well away from any wet area, floors dry and clear, any benches and shelves designed so that in the event of bumping into them in the dark you remain one whole conscious body. It is absolutely vital that any chemicals or dangerous items are kept out of reach of little hands or paws, preferably with the whole darkroom locked or at least the potential dangers kept safe in a lockable cupboard. It is advisable to be able to lock yourself in or devise a method that stops people entering whilst you are developing your once-in-a-lifetime masterpiece – kicking the drying cabinet is a poor substitute for a locked door! The cost of a bolt on the door is nothing compared to replacing a box of fogged paper when uninformed visitors stick their head round the door.

Consider painting the area around the enlarger matt black to avoid any light spills and the rest of the darkroom white, to make the most of the light from the safelight. This also helps to prevent a feeling of claustrophobia. Use a daylight balanced fluorescent tube as a room light if possible as these are easier to judge test strips and prints by.

The room will need to be light tight. The obvious source of light leaks will be windows and of all the ways to seal these areas, the simplest method is to use a black out material such as thick black felt, which can be held in place with Velcro. This is quick and easy to put up and remove, but doesn't involve any high calibre DIY skills. Making sure a door is light proof is no less important. Paint the inside edge of the door and its frame matt black and use a draught excluder; it works very well indeed unless the door has large gaps around it in which case you might like to use a thick black curtain as well. As a rule of thumb, the darkroom can be considered light proof if, after ten minutes in darkness, you are unable to see your hands in front of your face. This method may be basic but is extremely effective.

Equipping the Darkroom

It is possible to work in less than ideal conditions and most problems can be overcome one way or another. However, there are certain items that most photographers will find it difficult to live without. A well-designed darkroom should include a supply of hot and cold running water. A special darkroom sink that holds the processing trays and final wash is also extremely useful, enabling temperature control to be achieved by surrounding the trays with warm and cool water. An area such as this will also ensure that any spills that occur or utensils that require washing can be dealt with easily. If it isn't feasible or desirable to fit a sink of this kind, then a wet work area similar to a kitchen work surface will suffice, so long as you still have a sink that is large enough to allow you to wash prints. Be aware, however, with an arrangement of this kind, any chemical spills that occur on the work surface will need to be dealt with quickly.

A good adjustable safelight that can be positioned to throw some illumination into the most important areas is vital. Many photographers favour a light over the processing dishes or by the exposing areas or where the paper is stored. Fit more than one safelight if required, but check that anything you use is suitable for use with variable contrast papers – not all lights are. Refer to the manufacturer's guidelines for a minimum safelight distance to ensure fogging does not occur.

Photographic chemicals give off fumes, some of them dangerous, nearly all of them unpleasant. For this reason some form of ventilation for the darkroom is strongly recommended. Investigate whether it's feasible to fit an air filtration system and, in any case, make sure you take regular fresh air breaks.

If you are one of those people who hoard film and paper then a very useful addition to the darkroom is a fridge to keep everything in peak condition. If you require an extended storage period then a freezer is a better choice. Many professionals use this method and freezing seems to have no detrimental effect on paper or film.

On my workbench I like to have a lamp fitted with a daylight bulb to enable me to carry out retouching work and my trusty lightbox for negative assessment is kept nearby. I have to admit that I would be lost without a pinboard which is crammed full of notes on dilutions and times. The more your darkroom feels like a comfortable working environment the easier your work will become.

Tip: To make sure your safelight will not fog the material you are using, take a small piece of paper and give a brief exposure under the enlarger without a negative (just enough to produce a light grey tone). Place the paper as close as it is likely to be to the safelight, and place a coin or similar object on it. Leave in place for a period slightly longer than the maximum processing time and then develop in the normal way. If even the faintest outline of the object is visible then the safelight is unsafe. Fit a bulb of lower power and check that the safelight filter is of the correct type.

Michael Milton

03. Processing Equipment

Film processing essentials

a. Small 250ml measure
b. 3 x 1 litre measure
c. Larger 2 litre measure
d. Darkroom timer
e. Interval timer
f. Daylight developing tank
g. Film spirals
h. Thermometer
i. Hose-pipe fitting for the wash
j. Scissors
k. Film cassette bottle opener

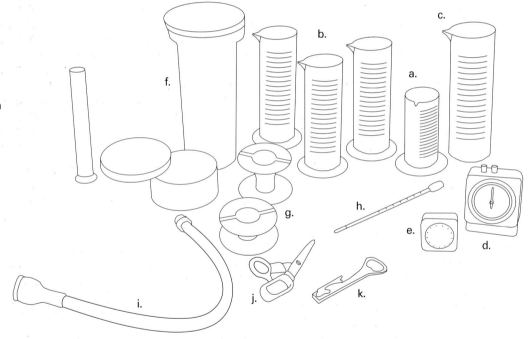

Basics for both film and paper

Ideally three measuring jugs in different colours or clearly marked for developer, stop bath and fix will ensure good practice, helping to prevent contamination. If each is a litre in size, that will be ideal. A smaller measure (250ml) is ideal for film developer and a larger two-litre capacity one for water. An accurate, easy-to-read thermometer is crucial, and a timer that will be visible in darkness is practical for film processing and paper. A second basic timer helps when timing the wash – a kitchen-style interval timer is particularly useful, giving an audible signal when the time is up. A hose-pipe style connection to the tap is best for the final rinse.

Film processing basics

Developing tanks are available in plastic or stainless steel with film spirals to match. Whichever material you choose the daylight tanks are the best. These allow you to pour the chemicals in and out with no danger of any light reaching the film. The film spirals themselfs are different in the way the film is loaded; plastic spirals are adjustable to cater for 35mm or 120 film and load the film working inwards whereas the steel versions load from the inside out and need individual 35mm or 120 sizes. When loading care must be taken to ensure that the spirals are clean and dry, particularly the plastic variety as the film will jam in them at the slightest hint of moisture. Steel, on the other hand needs a gentle hand when loading to avoid any kinks in the film. Steel is far more durable and is easier and quicker to dry.

Tanks come in a number of sizes. Make sure you choose one that will process the maximum number of films you are likely to process in any one go. This helps to provide consistent quality and saves time. A separate tank for developer, stop bath and fix is sensible if you process on a daily basis, otherwise scrupulous cleaning is required to ensure there is little chance of contamination. When it comes to film spirals always buy extra so that clean ones are at hand and it is also useful to have a spare in case of a jam. Beginners may find it helpful to practice loading a spiral with an unwanted roll of film in the light until the process becomes second nature.

Less essential items include a film squeegee (use with great care as the smallest particle of grit can cause severe damage) to wet emulsion and a water filter – either a cheap tap connection or canister type – which will help to keep the worst of the grime from the film (and paper) rinse.

A film cassette or bottle opener is needed for opening 35mm film cassettes and a pair of sharp scissors for trimming the ends. Film clips are the most reliable implements when hanging film to dry although clothes pegs, when used carefully, can be a good stand-by.

A clean, absorbent towel is essential to help prevent contamination and dry hands are vital when handling undeveloped film. A light-proof bag is useful at the loading stage to put the opened film in if you have to interrupt the process. A magnifying lupe is perfect for a close examination of negatives.

04. Print Processing Basics

Paper processing essentials

a. Small 250ml measure
b. 3 x 1 litre measures
c. Larger 2 litre measure
d. Darkroom timer
e. Interval timer
f. Thermometer
g. Hose-pipe fitting for the wash
h. Scissors
i. Four processing trays
j. Print tongs
k. Storage bottles
l. Blower brush
m. Retouching kit

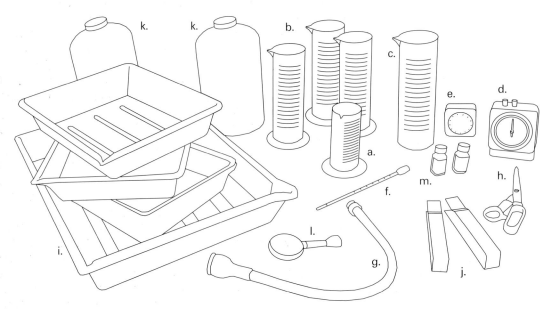

In addition to the basics mentioned earlier, print trays are an obvious requirement for the wet section of your darkroom. They come in a dazzling array of colours and sizes, but most needs are met with three trays (one each for developer, stop bath and fix). Sizes should relate to your choice of paper size with 10 x 12in and 16 x 12in being a popular choice and good to start with. Choose a suitably large fourth tray for the final wash. Use a different colour to allocate to each of the chemicals or mark white trays so there is no confusion. A print washer, is a very useful item for cutting down the wash time needed for fibre-based paper. In normal conditions it's not an item that's essential to have but if you do intend to process a lot of fibre paper and your water supply is on a meter you may find a washer will save you time and money in the long run.

A set of tongs are necessary for lifting prints in and out of the trays. Use different colours again or mark each one to avoid contamination. Storage bottles are handy for chemicals, the best being the accordion-style bottles that allow you to expel excess air as the chemicals are used. Tray thermometers and again a hose-pipe fitting for taps will also come in useful. You may also like to use a print drying rack or stick with a simple line and clips system – both are equally effective.

The dry side of paper processing, in addition to the enlarger and its accessories, is completed with a good spotting or retouching kit that includes one or two fine brushes for getting rid of marks on the print. A pair of large scissors is needed for cutting up test strips, while for making contact sheets a piece of glass or a special contact printing frame will also be necessary. The choice of which to use comes down to budget: the glass option is fiddly but inexpensive.

A paper safe can be a useful piece of equipment, giving quick access to paper and preventing accidental exposure – should the light be switched on with the box open, for example. A disadvantage is that you will need one for each type of paper you use. As I swap and change a fair bit, I prefer an accessible shelf with paper in the original boxes and I ensure everything is tightly closed before switching the room light on. I do however keep my most-used paper in a safe. A blower brush for removing dust from negatives is vital; 'canned air' is popular for dust removal but should be used on negatives with great care since over use can sometimes lead to the propellant getting on the negative. Cotton gloves can also prove useful when handling negatives and retouching prints. Other accessories will come to light as you progress, many being personal preferences rather than essentials.

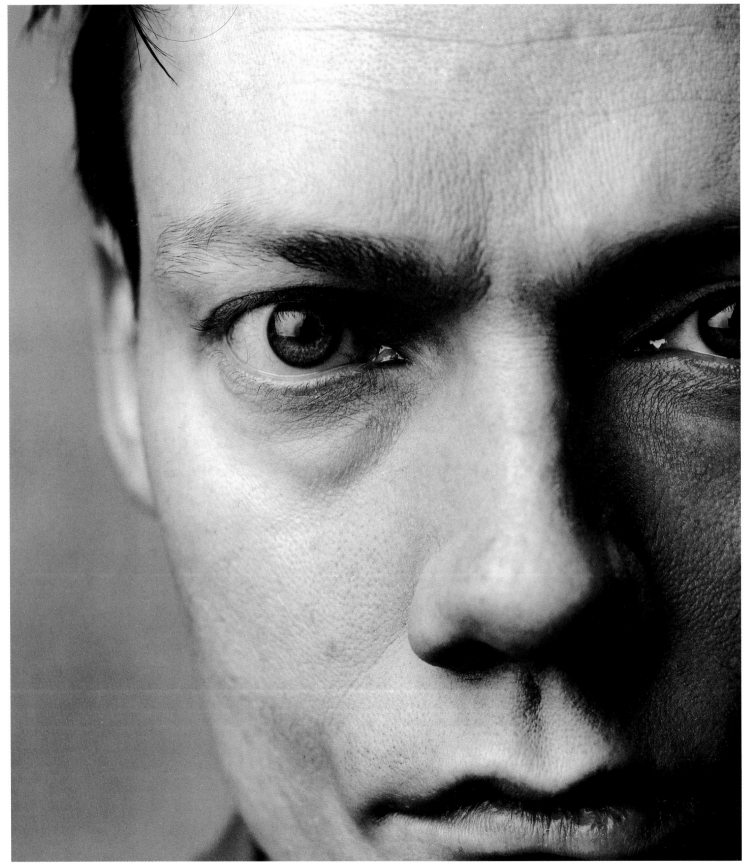

Matt Anker

Print: William Orbit

This startling portrait was taken by Matt Anker, one of the top photographers specialising in the music business. Some of the most striking album covers and band promotion photographs around today are by Matt, whose inspired images and dedication make him one of the most respected photographers in the industry.

Technical Details

This print was made on a diffuser enlarger with a variable contrast head using Ilford Multigrade IV paper. Matt's choice of enlarger is based on the fact that the majority of his work is portraiture and he prefers the light quality of the diffuser enlarger for skin tones. He used a grade 3 contrast setting and processed the print in Agfa Neutol WA, a warm-tone developer, to prevent the skin from looking too cold. The photo was taken with a Sinar P 5 x 4in camera using a 150mm lens.

The light of a condenser enlarger produces higher contrast and shorter exposure times.

The diffuser light source creates a softer illumination and is less revealing of dust and marks on the negative.

Enlargers

When choosing an enlarger the range available, both new and old, is vast and the only way to reach a decision is to assess features, price and reputation. However, there is one factor that is perhaps dominant in the choice of enlarger and that is light source. Enlargers offer a number of different light sources: the two of most interest are the diffuser and the condenser.

A diffuser enlarger uses a light source that is softer than the condenser, and is available with colour or variable contrast (VC) heads. The VC head allows easy adjustment of contrast by means of a dial – some models offer a constant exposure through all grades. Apart from the benefit of using variable contrast papers, these enlargers offer a light source that often masks dust and imperfections in the negative. They also soften the grain structure whilst retaining image sharpness. As a result of the diffused light source, exposure times are longer than for those of a condenser type. The diffuser enlarger is often preferred for light quality with all paper types. (It is possible to use a colour enlarger for variable contrast work, but it is less than satisfactory in practical terms as the exposure changes with different grades.)

Conclusion: As an all-rounder, a variable contrast enlarger with constant exposure is an ideal choice.

A condenser enlarger offers a smaller, more direct light source. Exposure times are normally quite short, contrast is higher and grain is enhanced. VC papers can be used with this type of enlarger by using special filters that fit either above or below the lens. This method is more time-consuming and cannot be as finely tuned as the diffuser method of dialling in different grades, but it is a good enlarger for fixed-grade papers and for photographers who prefer a 'harder' image.

Conclusion: These enlargers tend to be less expensive than the diffuser types, but the negatives need to be scrupulously clean and free from marks unless you wish to spend a good deal of time practising your retouching skills.

The other type of enlarger worth mentioning is the cold cathode. This enlarger offers very even and soft illumination – more so than the diffuser type. It is less popular than it used to be, mainly because the colour of the light source differs from other enlarger types and the use of VC filters and paper is less than straightforward. As a result it is most often used for fixed-grade paper.

Choice of illumination in an enlarger is very much a matter of personal preference; ultimately image quality is down to a combination of factors such as the quality of film, lenses and your familiarity with the equipment.

06. Format Options and Negative Carriers

The size of negative that you intend to use will influence enlarger choice, although many will allow you to print from a wide range of formats, allowing you to grow as a photographer and printer, without the limitations of a single format. If you intend to use a 35mm camera forever then a 35mm enlarger it is, but if you might like to dabble with medium format in the future then obviously the smaller format enlarger will be too restrictive a choice.

The negative carrier in the enlarger itself should also be considered. Whilst many are completely changeable, it is wise to check this, the best option being one that will accept both glass and glassless carriers. A glass carrier may well ensure a flat negative but at the cost of an additional four surfaces to keep dust free. A glassless carrier has the disadvantage of allowing the negative to buckle under the heat of the enlarger lamp, causing loss of sharpness in part or all of the image. This occurs less in the smaller negative sizes and can be reduced by using masking tape to keep the negative taught or by simply allowing a rest time or removing and replacing the negative in the carrier.

One final point is that the enlarger should be sturdy and the column long enough to allow you to make large prints in all formats that you may work with.

Lenses

Before any purchase is made, it is common sense to consider that a really good-quality lens will last a lifetime and give sharp and even illumination; a poor lens is a poor lens. Quality optics are by no means cheap, but to cut corners on this particular feature will leave a sour taste, and produce less than optimum enlargements. As a guideline a 35mm negative requires a 50mm enlarging lens and for 6 x 4.5cm and 6 x 6cm, you'll need an 80mm lens; in other words 'standard lenses'. Other sizes are used from time to time for these formats but they mainly involve specialist applications such as copying work and duping. A nice wide aperture assists focusing, with a 2.8 lens being four times as bright as a 5.6 optic. As a general rule, always stop down three stops as peak performance is around this area.

Timers

Ensure the timer for your enlarger will allow exposures from fractions of a second to a few minutes. Using a clock or wrist-watch is wildly inaccurate, making repeat exposures and shading very hit or miss. Double check that the timer has a facility to switch the lamp on and off independently of the timer function to allow for focusing and framing of the image.

Masking frames and focus finders

The job of the focus finder is to allow accurate focusing on the grain of the film. It is a good idea to look through several before you buy one as some are easier and more comfortable to use than others. If you need glasses, one that is adjustable for eyesight is a real help. Masking frames (or easels) come in various guises. The most popular is the two-bladed version, although four blades offer slightly more versatility. Choose one suitable for the enlargements you will be making, allowing room for the occasional larger print. Check that the paper is held nice and flat and adjustments are both easy to make and fine enough. A range of borders from 1/4–2in is suitable. A counterbalance leaves both hands free for inserting paper; again, try before purchasing, especially if you are choosing between a two- or four-blade version.

Basic requirements for the enlarging area

a. Enlarger
b. Masking frame
c. Enlarger timer
d. Focus finder

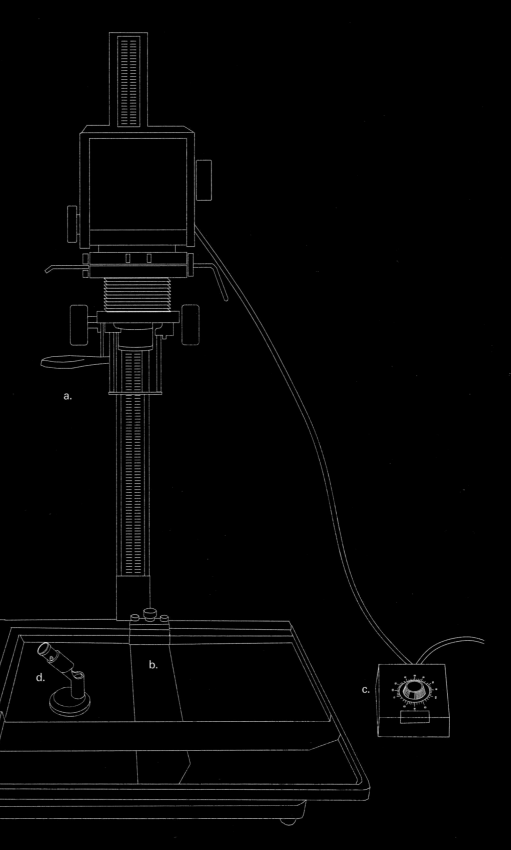

Films and Developers

By processing your own film, it is possible to take advantage of a film's characteristics, to change them or enhance them. Indeed, using different combinations of film and developer can result in a more personal approach to a new film or lead to rediscovering the qualities of an old favourite.

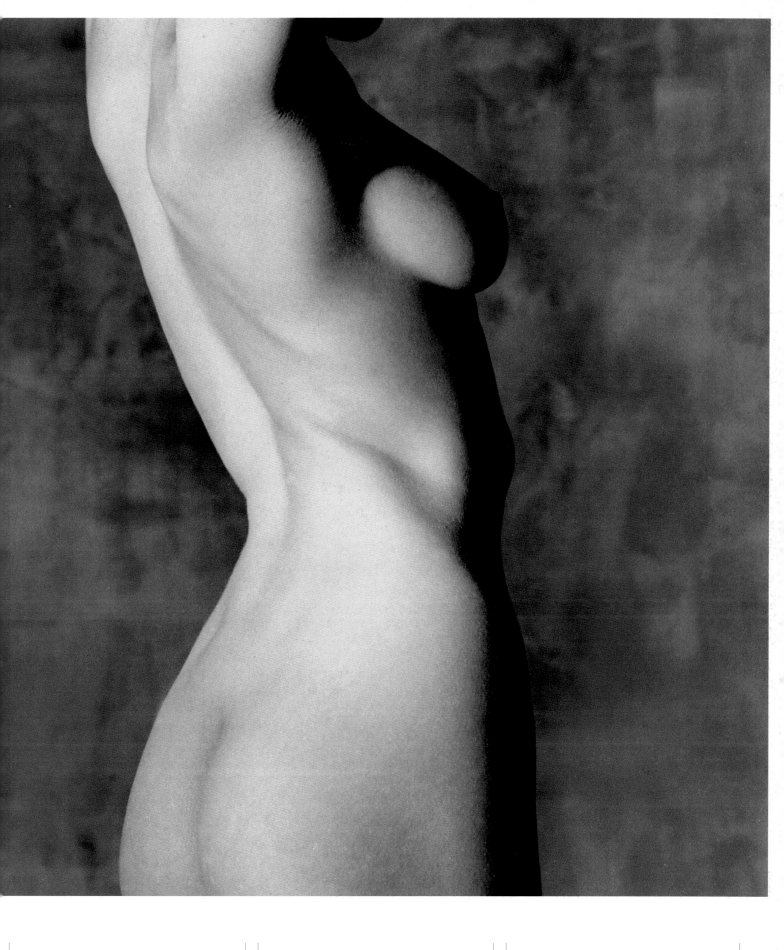

01. Film Types

Most black-and-white films fall within the range of ISO 25 to 3200.

Slow films, at the lower end of the scale, will tend to have finer grain, greater tonal range and better definition, ideal for landscape work, for instance. The slow speed of these films calls for the use of a tripod and cable release.

Medium-speed films are popular for studio work and location work where the extra speed will come in useful. Tonal range, definition and grain size are still very workable, and indeed, this speed of film is often popular with both landscape photographers and portrait specialists.

Fast films, at the top of the scale, become progressively more grainy and the tonal range can be more compressed when compared to a slow film. They are particularly useful for reportage techniques and any situation where speed is an advantage.

These are only rough guidelines and any speed of film whose characteristics you like should be thoroughly explored – breaking these somewhat loose rules is only likely to enhance your photographic and processing skills.

The characteristics of all film types can be considerably influenced by the way they are exposed and processed. The films that use newer emulsion technology, such as Ilford Delta and Kodak T-Max, offer exceptional grain size for their speed and a very good tonal range. It could be said that these films break the above guidelines for traditional emulsion types though these generalisations are still a good reference point.

The development process

For the majority of black-and-white films the development process consists of the following stages. The emulsion of a film is a layer of gelatine which contains light-sensitive silver salts. These change when exposed to light. This is not permanent or indeed visible until the film has been developed, turning the exposed silver salts to a black silver. The salts that have received no light, and are therefore unexposed, are not affected by the development process. These unexposed silver salts are removed from the film's emulsion by the fixer. Emulsion technology is changing and many new films are appearing on the market. They boast finer grain structures and improved exposure latitudes, but they all follow this process.

The one exception to this is chromogenic film which is processed in colour negative chemistry (C-41) which produces a dye image. Ilford's XP1 was the ground breaker in this respect, but in recent years the other major manufacturers have released their versions of this, and Ilford has upgraded its original one to XP2 Super. These particular film types offer some desirable characteristics: a fast ISO 400 speed, yet a very fine-grained image; good tonal gradation and tolerance of exposure error. Ilford's XP2 also produces an interesting 'silvery' quality that I find really quite mouth-watering. But if all this sounds a little too good to be true, then consider the longevity of a correctly-processed silver image to be measured in 100 or more years as opposed to a dye image where longevity is considerably less.

Standard emulsions do allow more versatility in processing and through varying developer types, dilutions and processing times you can select a film and developer combination to suit your own personal style.

Print: Dr. Smart's Gardens, Devon, UK

This shot was made using Ilford's XP2 Super film. I opted for this film because of a number of factors. The first was to accurately record the marvellous range of tones – very few films can match XP2 for producing maximum tonal range and smooth gradation in all areas. I also needed a fast film to counteract the very windy weather – a slower film would have produced a blurred effect in the trees, something I wanted to avoid. Finally, I needed to retain as much clarity as possible and did not want any film grain to be intrusive in this picture – XP2 despite its ISO 400 speed gives a very fine grain. These factors gave me the image I wanted.

Technical Details

I used a 6 x 4.5cm SLR camera with an 80mm lens to take this shot. Exposure was 1/30 second at f22. The film was Ilford's XP2 Super developed in C-41 chemistry.

Julien Busselle

02. Developers

Developer choice should be related to a film's speed, its characteristics and the effect you wish to achieve. Each type of developer will have a particular characteristic and you can best familiarise yourself with these through experimentation.

A **fine-grain** developer produces a sharp image and tight grain pattern with no significant effect on film speed. A good all-rounder, this type of developer is particularly useful with all film speeds. Although there are many examples of this type of developer, timeless and popular favourites are Kodak D76, HC110 and Ilford's ID11. These are often only available in somewhat large quantities for occasional use. In this case, a small one-shot developer like Ilford's Ilfosol-S is a good choice.

Super-fine grain developers are also available, providing a very tight grain pattern, and are often used when making very large prints, but as a general rule these can cut the speed of the film emulsion by as much as a stop or more. I have used Ilford's Perceptol as an example of this type of developer. It has many fans and is a very popular and reliable formula.

High-acutance developers provide high to extreme 'edge sharpness', and a good grain pattern, although grain size is slightly increased. For this reason you might prefer to use this type of developer with slow- and medium-speed films. One of my favourite examples is the classic Agfa Rodinal. It would not be an overstatement to say that many regard it as the finest acutance developer available.

It is possible to gain film speed by the use of a **speed-increasing** developer such as Ilford Microphen. These developers work actively in the shadow areas of the picture, compensating for underexposure. Grain size is increased and the tonal range can become compressed. Although a useful developer on occasions, it is no substitute for a good fast film.

Experimenting with different combinations of film and developer is a good way of becoming familiar with the characteristics of both. You may like to enhance the grain in a fast film, for instance, or increase the sharpness of a very slow film by the use of a high-acutance developer. In addition, by processing your own films these options – and more – become easily achievable. Ultimately, these choices will depend upon the size and style of the prints you aim to produce.

The above examples of developers are based on long-established formulas and are arguably more suited to experimentation than some newer formulations, if for no other reason than their classic properties. More modern developers such as Kodak T-Max are best used in conjunction with the film they are designed for, allowing all the properties of the film to shine through. As before, these are guidelines only and please don't let that get in the way of a good time!

Julien Busselle

Print: Towards Georgeham, UK

This scene was lit by a bright autumnal sun which was slightly diffused, creating a good tonal range without excessive contrast. To capture the full range of tones and emphasise the texture of the foreground I chose Agfa's Agfapan APX25 film and made an exposure of 1/8 second at f22. APX25 is an extremely sharp, fine-grained film. I developed the film in Agfa Rodinal, a high-acutance developer, to emphasise the sharpness and to maintain the crispness of the scene. The sky is almost completely free of any film grain in the original 16 x 12in print and the razor-sharp detail in the foreground adds to the overall texture. This particular combination is one of my favourites but the very slow film speed, just ISO 25, means that in conditions when the use of a slow shutter speed could create a problem, I switch to a faster film.

Technical Details

This shot was taken on my 6 x 4.5cm SLR camera with a 55mm lens; 1/8 second at f22. The film, Agfapan APX25, was developed in Rodinal for 6 minutes at 1 to 25 dilution.

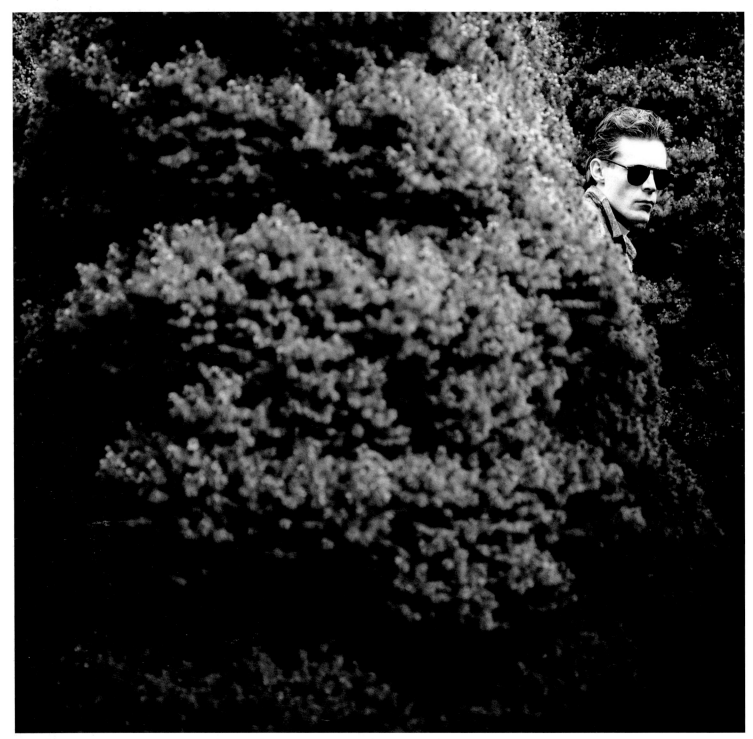

Matt Anker

Print: Andrew Eldritch, The Sisters Of Mercy

Matt Anker used Kodak T-Max 100 film to capture this candid portrait of Andrew Eldritch. Smooth tones and unobtrusive grain were the important factors in helping to capture skin tones while allowing the texture of the foliage to shine through. Known for his intensity, Andrew Eldritch was placed by Matt to give a slightly more humorous approach to the picture whilst still retaining an element of mystery. The wide aperture used puts the emphasis on the face whilst the out-of-focus foliage still adds texture and acts as a form of border.

Technical Details

6 x 6cm SLR camera with a 120mm lens; 1/125 second at f5.6. Kodak T-Max 100 processed in T-Max developer for 6 1/2 minutes at 1 to 7, at a temperature of 24 degrees C.

Print: Femme Fatale

This picture, by Michael Miller, blends both classic and modern. Michael is a very talented and inventive young fashion photographer. His film choice in this case was Kodak T-Max P3200, an extremely fast film, normally preferred for use in low-light situations but in this case Michael used the film for its grain effect. The grain size added to the feel of the photograph and to accentuate the grain further the film was pushed one stop to 6400 and development was extended. The film was processed in Kodak T-Max developer.

Technical Details

35mm SLR with an 85mm lens; 1/2000 second at f1.4. Kodak T-Max P3200 uprated to ISO 6400, processed in T-Max developer diluted 1 to 4 for 11 minutes at a temperature of 24 degrees C.

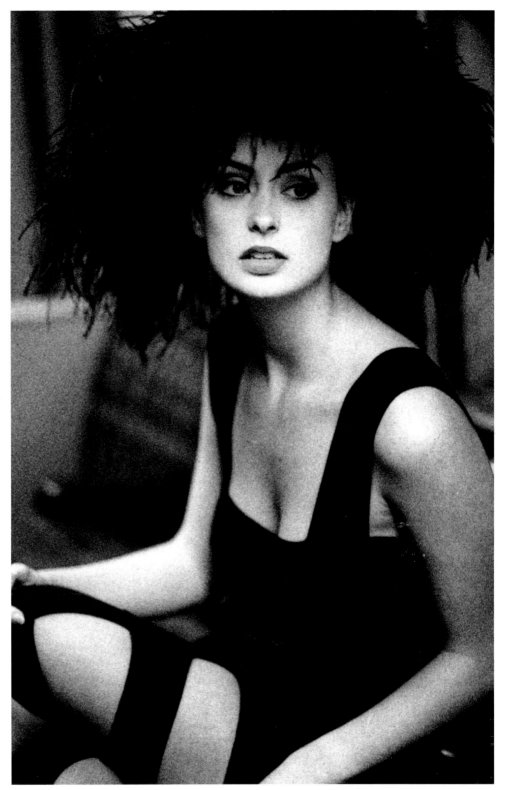

Michael Miller

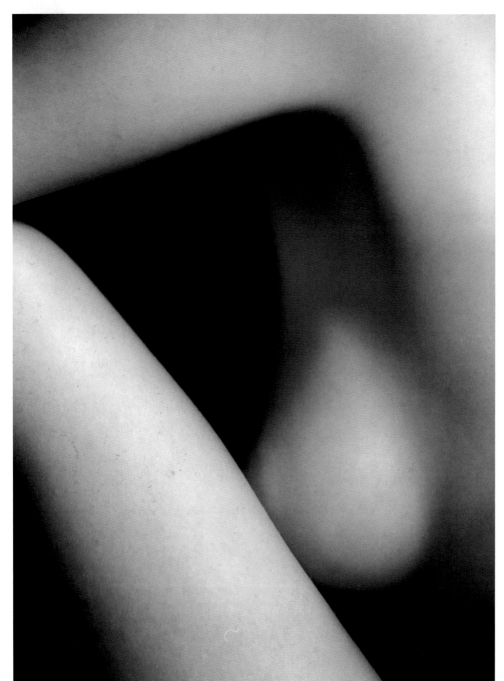

Michael Milton

Print: Nude Study

These two pictures by Michael Milton are good examples of careful film selection. For the nude study Michael chose Ilford's FP4+ film. The smooth rendition of the skin tones was paramount and although the speed of the film was perfectly adequate in terms of exposure, the film was pushed two-thirds of a stop to ISO 200 and extra development was given to increase the contrast slightly. This additional contrast was necessary to give extra body
to the shot under soft lighting conditions, but the smoothness of FP4+ was retained.

Technical Details

35mm SLR with a 200mm lens; 1/60 second at f11. The film was Ilford's FP4+ developed in Ilfosol-S for 5 minutes.

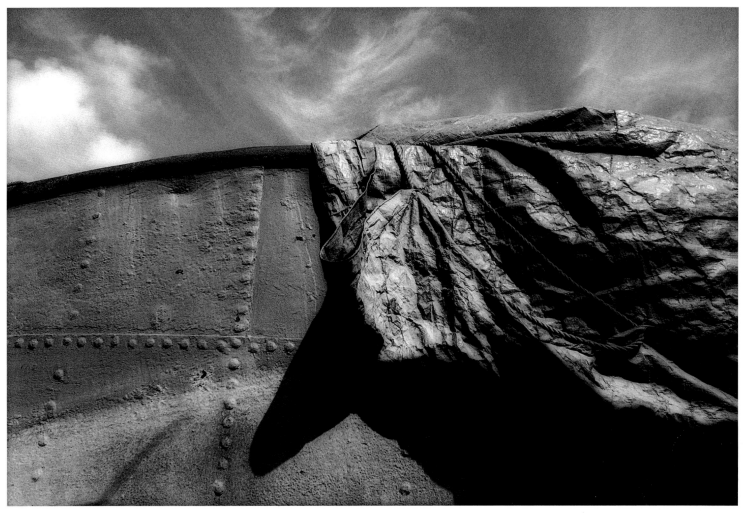

Michael Milton

Print: Side of boat and tarpaulin

In this shot of draped tarpaulin, Michael's film choice was Kodak Tri-X – his favourite. The film was chosen because of its contrast and grainy quality. The fast ISO 400 speed also has a benefit in that Michael shoots without a tripod, preferring a minimalist approach, with only a camera and 28mm lens for his travels in the countryside.

Technical Details

35mm SLR with a 28mm lens. Exposure was 1/125 second at f8. The Tri-X film was developed in Ilford's Ilfosol-S for 9 1/2 minutes.

Section 3

Processing Film

Processing your own film opens up many options, is relatively quick and easy, and very satisfying. It also gives a greater understanding of exposure control and is the first step in controlling the style and quality of the finished print.

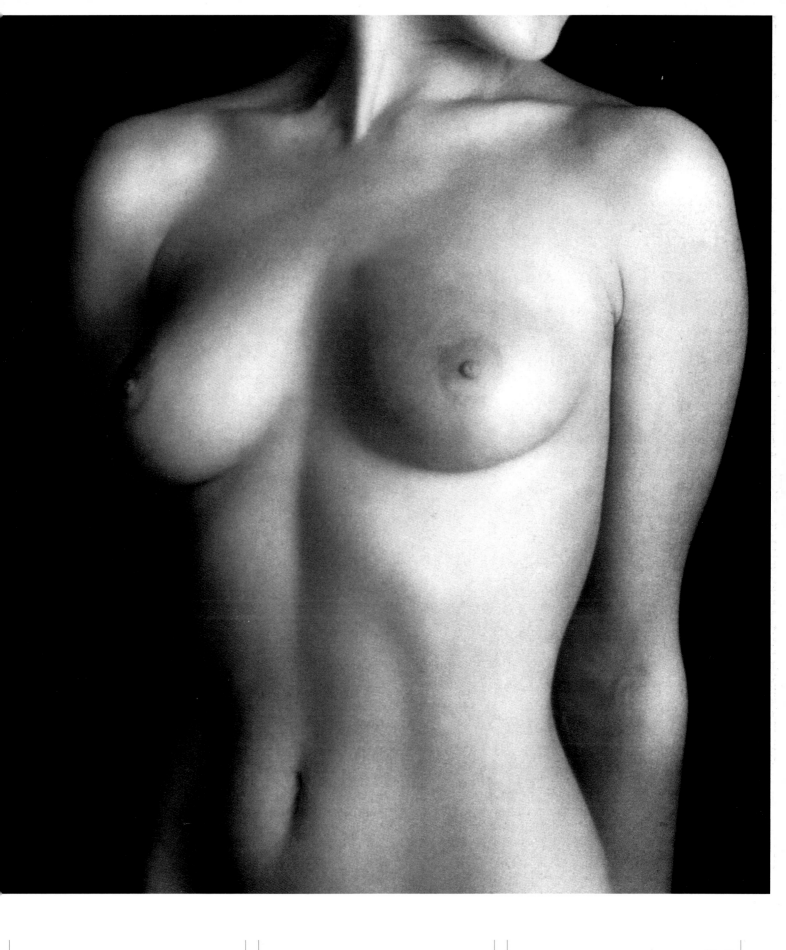

Development Chart

Ilford Pan-F (ISO 50)
Fine-grain developers

Ilford ID11 (1+1)	8:30 mins
Ilford Ilfosol-S (1+9)	4:00
Kodak D76 (1+1)	10:30
Kodak HC110 (dilution B)	4:00

Super-fine grain developer

Ilford Perceptol (1+1)	15:00

Acutance developer

Agfa Rodinal (1+25)	6:00

Ilford FP4+ (ISO 125)
Fine-grain developers

Ilford ID11 (1+1)	8:00 mins (35mm)	11:00 (120)
Ilford Ilfosol-S (1+9)	4:00	6:30
Kodak D76 (1+1)	8:30	11:00
Kodak HC110 (dilution B)	5:00	9:00

Super-fine grain developer

Ilford Perceptol (1+1)	14:00	15:00

Acutance developer

Agfa Rodinal (1+25)	6:00	9:00

Ilford HP5+ (ISO 400)
Fine-grain developers

Ilford ID11 (1+1)	13:00: mins
Ilford Ilfosol-S (1+9)	7:00
Kodak D76 (1+1)	11:00
Kodak HC110 (dilution B)	5:00

Super-fine grain developer

Ilford Perceptol (1+1)	15:00

Acutance developer

Agfa Rodinal (1+25)	6:00

Ilford 100 Delta (ISO 100)
Fine-grain developers

Ilford ID11 (1+1)	11:00: mins
Ilford Ilfosol-S (1+9)	6:00
Kodak D76 (1+1)	12:00
Kodak HC110 (dilution B)	6:00

Super-fine grain developer

Ilford Perceptol (1+1)	17:00

Acutance developer

Agfa Rodinal (1+25)	9:00

Ilford 400 Delta (ISO 400)
Fine-grain developers

Ilford ID11 (1+1)	10:30 mins (35mm)	11:30 (120)
Ilford Ilfosol-S (1+9)	9:00	10:00
Kodak D76 (1+1)	10:30	11:30
Kodak HC110 (dilution B)	7:30	8:30

Super-fine grain developer

Ilford Perceptol (1+1)	18:00	20:00

Acutance developer

Agfa Rodinal (1+25)	9:00	10:00

Kodak Plus-X (ISO 125)
Fine grain developers

Ilford ID11 (1+1)	8:00: mins
Ilford Ilfosol-S (1+9)	7:00
Kodak D76 (1+1)	7:00
Kodak HC110 (dilution B)	5:00

Super-fine grain developer

Ilford Perceptol (1+1)	8.30 (Film rated at ISO 64)

Acutance developer

Agfa Rodinal (1+25)	6:00

Kodak Tri-X (ISO 400)
Fine-grain developers

Ilford ID11 (1+1)	11:00: mins
Ilford Ilfosol-S (1+9)	10:00
Kodak D76 (1+1	10:00
Kodak HC110 (dilution B)	7:30

Super-fine grain developer

Ilford Perceptol (1+1)	12:00 (Film rated at ISO 200)

Acutance developer

Agfa Rodinal (1+25)	7:00

Kodak T-Max (ISO 100)
Recommended developer is of course T-Max for all T-Max films, but if you feel like experimenting here are some figures.

Fine-grain developers

Ilford ID11 (1+1)	11:00: mins
Ilford Ilfosol-S (1+9)	8:30
Kodak D76 (1+1)	12:00
Kodak HC110 (dilution B)	7:00

Super-fine grain developer

Ilford Perceptol (1+1)	13:00

Acutance developer

Agfa Rodinal (1+25)	5:50

Kodak T-Max (ISO 400)
Fine-grain developers

Ilford ID11 (1+1)	10:00: mins
Ilford Ilfosol-S (1+9)	7:30
Kodak D76 (1+1)	12:50
Kodak HC110 (dilution B)	6:00

Super-fine grain developer

Ilford Perceptol (1+1)	12:00

Acutance developer

Agfa Rodinal (1+25)	5:00

Agfapan APX25 (ISO 25)
Fine-grain developers

Ilford ID 11 (1+1)	10:00: mins
Ilford Ilfosol-S (1+9)	6:00 (Film rated at ISO 20)
Kodak D76 (1+1)	11:00
Kodak HC110 (dilution B)	6:00

Super-fine grain developer

Ilford Perceptol (1+1)	10:00 (Film rated at ISO 20)

Acutance developer

Agfa Rodinal (1+25)	6:00

Agfapan APX100 (ISO 100)
Fine-grain developers

Ilford ID11 (1+1)	13:00: mins
Ilford Ilfosol-S (1+9)	7:00
Kodak D76 (1+1)	12:00
Kodak HC110 (dilution B)	7:00

Super-fine grain developer

Ilford Perceptol (1+1)	12:00

Acutance developer

Agfa Rodinal (1+25)	8:00

Agfapan APX400 (ISO 400)
Fine-grain developers

Ilford ID11 (1+1)	14:30: mins
Ilford Ilfosol-S (1+9)	9:00
Kodak D76 (1+1)	14:00
Kodak HC110 (dilution B)	6:00

Super-fine grain developer

Ilford Perceptol (1+1)	16:00

Acutance developer

Agfa Rodinal (1+25)	7:00

Fuji Neopan 400 (ISO 400)
Fine-grain developers

Ilford ID11 (1+1)	9:30: mins
Ilford Ilfosol-S (1+9)	6:30
Kodak D76 (1+1)	9:30
Kodak HC110 (dilution B)	5:00

Super-fine grain developer

Ilford Perceptol (1+1)	14:00

Acutance developer

Agfa Rodinal (1+25)	6:00

Film Speed

Whilst the film speeds suggested by manufacturers are linked to their recommended processing times, there may be occasions when you will want to alter this. If you are new to processing your own film, then it would be preferable to familiarise yourself with the process and to achieve an ideal negative at the recommended film speed before altering development times and ISO ratings. For this reason I have chosen to explain briefly what happens when these factors are altered rather than give specific figures, although included in the development chart are some deviations from ISO ratings.

'Pulling' film speed

This technique involves lowering the ISO rating to make the film slower by reducing the development time. Pulling the film will lower the contrast of the negative. It is ideal for gaining a more printable negative from a scene that may under normal circumstances be too contrasty to cope with your film choice. Using an ultra-fine grain developer can also reduce film speed but without affecting contrast.

'Pushing' film speed

Pushing a film increases its speed (the ISO rating) by extending the development time. This is the more common of the two techniques; it increases the contrast level and will make the film more grainy. The more you push a film the greater the contrast and grain will become. Gaining film speed can be extremely useful and the increase in contrast is ideal if the scene is particularly flat and lifeless. The increase in grain size can also be desirable in certain circumstances by enhancing the mood of a scene. A good example of this is 'Femme Fatale' by Michael Miller on page 37. A film's ISO rating can also be increased by using a speed-enhancing developer.

Checklist and Development Chart

The following checklist contains the equipment you need to process a roll of film, and the chart opposite is a guide to the development times of some of the most popular films and developers. These have been chosen because of availability and quality. The range of black-and-white films and developers is very wide and the chart may not contain your film or solution. If there are no guidelines included with the packaging, then test a small amount of the film first using a development time based on the nearest combination.

The development chart is primarily based upon manufacturers' recommendations and the film at its stated speed – the exceptions to film speed are clearly marked. All times are based upon a development temperature of 20 degrees C and agitation for 5 seconds every 30 seconds. The vast majority of black-and-white films and developers come with very good instructions, which normally advise on the most appropriate agitation times and frequencies. Whilst every effort has been made to check the accuracy of the chart, if you have information with your film it would be sensible to check it against the figures here. Where the manufacturer has specified a variation in times for 35mm and 120, separate figures are recorded. The chart is a guideline only and because of the variables involved, you are likely to need to do some fine-tuning to get your ideal negative. However, this is one of the advantages of being able to do your own processing.

Development checklist

Thermometer
250ml measure
3 x 1 litre measure
Daylight processing tank
Film spirals
Timer
Scissors
Bottle opener
Film clips
Developer solution
Stop bath
Fixer
Wetting agent

Processing Guide

Before processing begins, make sure you have everything you need to hand. It goes without saying that wherever you intend to process your film must be light tight – anything less than truly dark and you risk fogging the emulsion.

For demonstration purposes, we have opted to show 35mm film with plastic spirals that have a self-loading mechanism (small bearings that grip the sprocket holes of 35mm film), as well as stainless steel spirals. With roll film, loading is more manual, as explained in the text, and because of its larger size extra care needs to be taken to avoid buckling the film.

Preparing to develop

Mix the chemicals to the correct dilution and temperature, ensuring you have the quantity needed to cover the film completely in your developing tank. The chemicals can be kept at the correct temperature (20 degrees C) by placing the measures in a bowl of water at the same temperature. This prevents any major fluctuations for a limited time by providing a good level of insulation. You can, of course, mix the stop bath and fix beforehand as the temperature for these is less critical than the developer, but it's wisest to mix the developer at the very last minute.

Steps in darkness
Loading plastic spirals

Adjust your plastic spiral for the format you are using – 35mm or roll film.

Trim the ends of the film to make loading easier – if the film is wound back into the cassette, release the top with a film cassette opener (or bottle opener). Remove the film and hold gently in the palm of your hand to prevent it unravelling.

Holding the film end between thumb and forefinger, feed the film into the spiral. Use the lugs at the side as a guide. Take care to do this gently to avoid damaging the emulsion.

Load the film by turning the sides of the spiral alternately to and fro. If the film should stick try releasing it a little and continuing or start again. With 120 roll film the only way to load a plastic spiral is by applying very gentle thumb pressure as you load – it is far easier than it sounds.

Once the film is loaded cut the end to free it from the cassette.

Place the loaded spiral onto the spindle and place in the developing tank. Lock the top into its light-tight position, placing the lid on securely before turning on the light.

Loading stainless-steel spirals

Stainless-steel spirals cannot be adjusted and don't have guide lugs therefore loading needs a little more practice.

First fix the end of the film to the spring clip at the core of the reel.

Next gently bow the film and turn the reel so the film feeds into the spiral from the middle outwards. At the end cut off the spool. The rest of the process is the same as for using plastic spirals.

Steps with the light on

These steps can only be performed with the light on if you are using a daylight developing tank. These will allow the chemicals to be poured in and out again without the light reaching the film. Ensure that the top lid is on securely before agitation begins otherwise there's a danger that the chemicals will seep out and run down your arms.

Finally, once the film is thoroughly dry, cut it into strips to fit the negative bag. Storing the film in a negative bag ensures it is kept clean and protected from dust and scratches. The best types are those that are archivally sound, helping to prevent the film coming into contact with substances which may reduce its lifespan. Storing the negatives in an envelope is an open invitation to damage.

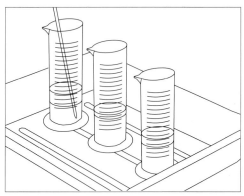

Check the temperature of the chemicals, especially the developer.

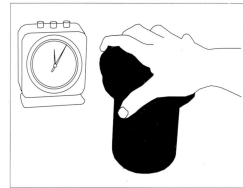

Smoothly pour the developer into the tank, securing the lid, and start to time the development.

Agitate the tank for the first 30 seconds of the development and then for five seconds every 30 seconds thereafter, or as recommended for your developer. Agitation is best done by inverting the tank. It is important to follow all agitation by gently but firmly tapping the base of the tank on the side of the sink or on the bench. The tapping releases air bubbles that can cause uneven development.

Pour out the developer a few seconds before the end of the development time. Development will continue until the stop bath is added.

Add the stop bath and agitate for 30 seconds before pouring out. Save the stop bath as it is reusable.

Add the fixer and agitate for 30 seconds and then for five seconds every 30 seconds until the fix time is complete. Once again save the fix as it is reusable.

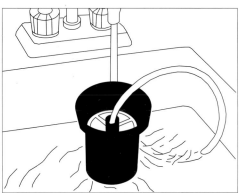

Wash the film by inserting a hose into the bottom of the tank. Usually a wash of 30 minutes is sufficient but wash times do vary so check first, bearing in mind that over washing is preferable to under washing.

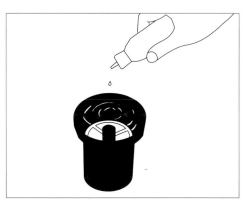

Once the wash is complete add a few drops of wetting agent and hang the film up to dry. If you want to squeegee your film, ensure the blades are free from even the minutest particle of dust or dirt.

03. Achieving a Good Negative

Assessing the negative for density and contrast is vital for working out the suitable development time. Although manufacturers' figures are aimed at producing a negative of ideal contrast, we are only human and the way the film is agitated during development, or a variation in temperature are just two of the things that can affect the quality of the final negative. It is important to follow guidelines and to stick with them routinely. If the final result is not satisfactory then consider altering the development.

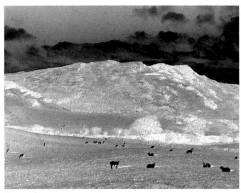

A well-exposed and properly developed negative will show a good density and contrast range. The detail in the shadow areas is clearly visible, and the highlight areas show good depth and body. Overall the negative shows a good, full range of tones.

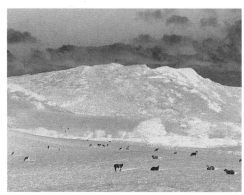

An underdeveloped negative is thin and the tones are muted. In particular the highlights are weak and shadow areas have less depth. Looking at the whole negative it lacks punch because of its low contrast.

Over development causes a dense negative, with poor detail in the highlights. The shadow areas have also become too dense. The contrast level has increased and the full range of mid tones is lost. In addition the grain becomes more noticeable.

To avoid confusion I have included examples of correct development but incorrect exposure. In this negative, which is underexposed, the effect is of a weak, thin negative. The easiest way to tell an underexposed negative from an underdeveloped negative is by looking at shadow detail. The underexposed negative has virtually no shadow detail.

Overexposure but correct development causes a dense negative that produces a flat print. Highlight detail is poor whilst there is slightly more shadow detail when compared to an overdeveloped negative.

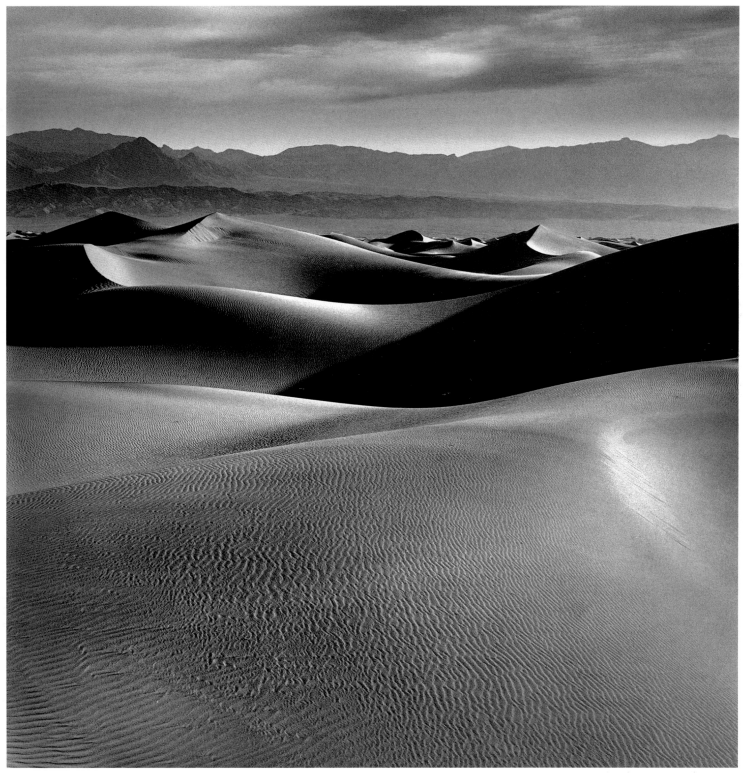

Tony Worobiec

Print: Undulating Sand Dunes, Death Valley, U.S.A.

This shot by Tony Worobiec demonstrates his first-class technique. By ensuring that the perfect exposure is followed by the correct development he has achieved a very atmospheric print with full tonal range. Tony is an exceptional fine art photographer and it is his knowledge and familairity of exposure and materials that enables a final print of such quality.

Technical Details

6 x 6cm TLR camera with a 55mm lens and an orange filter to lighten the sand and darken the sky. The film used was Kodak T-Max 400 (rated at ISO 280 to achieve the quality he wanted), developed in T-Max developer.

The print was made on Ilford Multigrade IV in a gloss finish, processed in Multigrade developer. Paper grade was 3 and the enlarger was a condenser type.

Section 4
Processing Paper

The print is the photographer's way of expressing the image to others in a very personal way. An individual style develops where contrast, exposure, paper and developer choice all work together to create the desired image. Printing your own images is one of the most rewarding aspects of black-and-white photography.

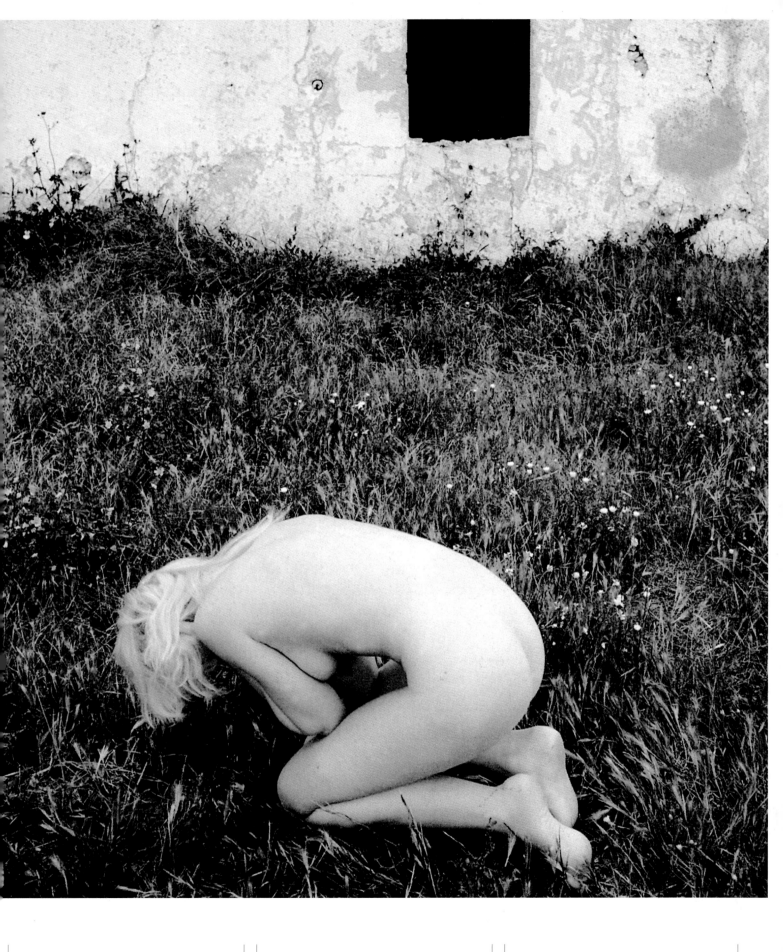

01. Paper Types and Developers

At first the range of black-and-white papers can be daunting, but in practical terms they can be placed into the following categories.

Resin-coated (RC) paper

This particular type of paper offers some considerable benefits. Due to the plastic coating the paper absorbs and therefore retains less chemicals than a fibre-based paper. In effect this means that processing and particularly wash times are significantly shorter. The coating also serves to protect the paper, making it more durable, and it enables the print to dry very quickly. Another advantage is that the print dries very flat indeed. These papers are particularly favoured when the picture is to be reproduced.

Fibre-based papers

A more traditional paper, this does have the disadvantage of a slightly longer processing time but a much longer wash time than RC paper.

The surface is more fragile and a gloss finish on a fibre-based paper is not nearly as shiny as its resin-coated counterpart. The drying time is far longer and the prints have a tendency to curl. This varies from paper to paper but most fibre-based prints will need to be flattened under a heavy weight to get an acceptably flat finish. What a fibre-based paper does offer, when correctly processed, is a very long-lasting image and a very attractive print quality; it also responds well to toning techniques. For exhibition and portfolio work this paper takes some beating.

Each type of paper has its loyal supporters. Many would never use a paper with a plastic coating while others argue that fibre-based paper users are only making hard work for themselves. Many of course, habitually use both. It really does come down to that much-repeated term 'personal preference'.

Resin–coated (RC) paper

Fibre–based paper

Variable-contrast (VC) papers

Traditionally, black-and-white papers came in a fixed grade of contrast: soft, medium and hard, or grades 2, 3 and 4 – simple enough. Many papers, more notably fibre-based ones, are still like this and some of the finest papers available are fixed-grade papers, the likes of Agfa Record Rapid and Ilford Gallerie being prime examples.

Variable-contrast papers allow a full range of contrast grades controlled by the use of special filters; instead of changing papers you change filters for different levels of contrast. Contrast factors normally range from 0 to 5. These papers offer greater control over the contrast of a print and you often have a half grade option which can be useful. Being able to use a combination of grades for one print, known as split grade printing, is a more advanced technique to be fully explained in another volume. Tony Worobiec has used this in his print 'Field of Sunflowers', pages 90 – 91 and explains why.

One factor that is most likely to be of interest for those new to printing is that a single box of VC paper will cover all grades and eventualities, whereas when using a fixed-grade paper you would need soft, medium and hard which works out considerably more expensive in the early stages. Once you become accustomed to printing it is easier to select paper grades to complement your usual contrast range, although it is always sensible to cater for the unexpected. Most manufacturers offer both fibre-based papers and RC papers with a variable-contrast option.

Paper developers

Paper developers are less varied than those used for film. Variable-contrast papers normally have a matching developer that brings out the full contrast range within the paper. However, it is by no means essential that you have to use these together. The developers for paper can also have an option for a neutral print, one with a slight warm tone or the other with a cold tone. These developers have only a very small effect and a warm tone or cold tone will only give a slight hint: do not expect a significant brown or blue tint.

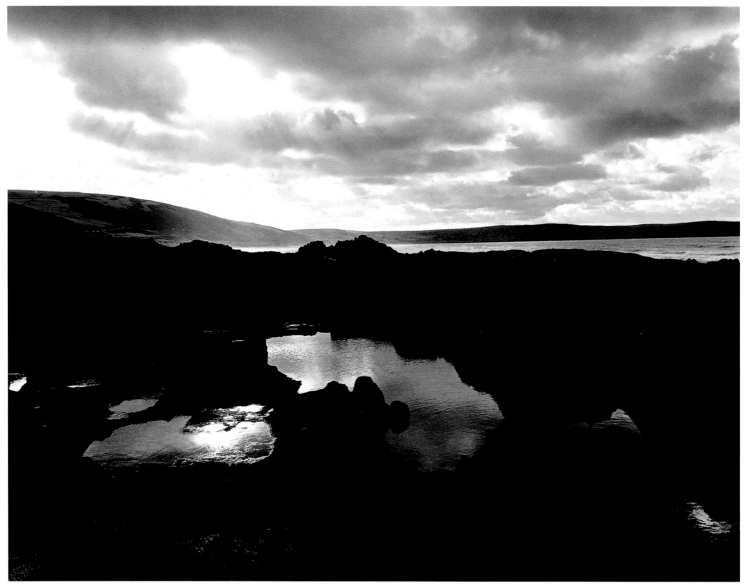

Julien Busselle

Tip: When using fibre-based paper it is vital to ensure the print is thoroughly washed to remove all traces of the fix, making the print archivally sound. A long wash may be all that is required, but I prefer to immerse the print in a hypo clearing agent or a wash aid for a few minutes after the first 10 minutes of the wash time. I then continue to wash the print for the remaining full time after treatment. This will cut the wash time if the wash is close to 20 degrees C, but since most people's wash is of a much lower temperature, the full time allows a margin of error.

Print: Rock Pools at Twilight, Barricane Beach

This print was made on a fibre-based paper that used variable contrast technology. It provides easy contrast control and the print quality that I prefer to a plastic-coated paper for my exhibition work. The fibre base also has another slight edge, to my mind – it feels wonderful!

Technical Details

6 x 4.5cm SLR camera; 45mm lens with an orange filter; 1/15 second at f22. Ilford XP2 Super developed in C-41 chemistry.

Print Details

Ilford Multigrade IV fibre-based paper with a warm tone. Contrast was grade 3 and the basic exposure was 15 seconds at f8 on a diffuser enlarger with a VC head. The print was processed in Multigrade developer for 2 minutes at a dilution of 1 to 9.

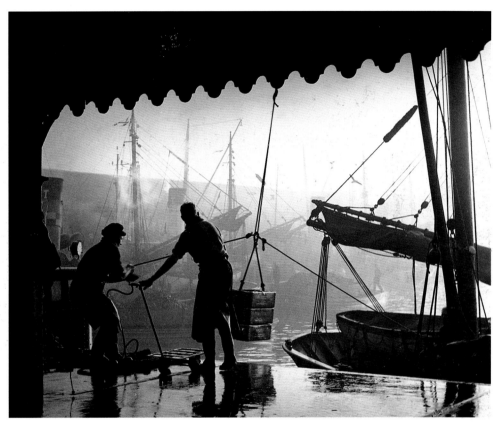

Sid Reynolds

Print: Busy Harbour

This print by Sid Reynolds captures the activity in a fish market as boxes of herrings are unloaded. The atmosphere was heightened by the creeping mist in the harbour, making careful exposure essential. Sid is never one for taking the easy way out when it comes to getting the image he wants. He uses a 6 x 6cm twin lens reflex camera even on a boat in stormy seas, when many would opt for an auto-focus camera, or stay at home!

Technical Details

6 x 6cm TLR camera; 1/100 second at f7. Ilford's FP4 film (ISO 125) developed in Microdol.

Print Details

Sid used an enlarger with a condenser light source for this print. All his exhibition work is made on fibre-based paper; he has a particular fondness for Agfa Record Rapid. For reproduction, however, Sid made this print on Ilford Ilfospeed, a fixed-grade resin paper. Exposure was 30 seconds at f8 with grade 4 paper developed in Ilford PQ Universal.

Making a Test Strip and Contact Sheet

Making a Test Strip, Method 1
A test strip is used to give an idea of the correct exposure for a contact sheet or print. It saves wasting paper trying out different exposure times and is most effective when carried out using a large strip of paper; small strips are difficult to judge.

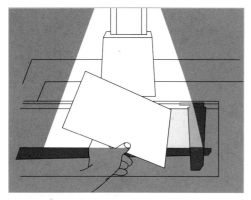

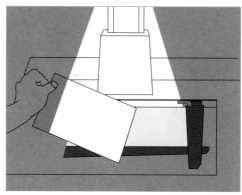

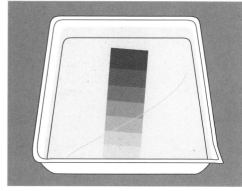

The procedure shown here shows a test strip for a print but also applies to contact sheets. First set up your enlarger for a print (p.58) or for a contact sheet (p.57). Take a large strip of paper and cover this with a sheet of card, leaving one-fifth exposed. Now expose for 5 seconds.

Reveal another fifth of the paper and expose for a further 5 seconds, repeating this procedure until all the paper has been exposed.

The developed strip will show a range of exposures from 5 to 25 seconds. If all are too dark try closing the lens aperture a stop or two; if all are too light open the lens a stop or two. This is a simple way of making a test strip and many other methods exist; I have given a more thorough but less straightforward version below.

Making a Test Strip, Method 2
This test strip is sometimes called a zonal test strip. Give a basic exposure to the whole of the test strip of 5 seconds, then progressively cover the paper giving exposures of 2, 3, 4, 6, and 10 seconds. This will give a test strip in which the stages represent exposures of 5, 7, 10, 14, 20 and 30 seconds.

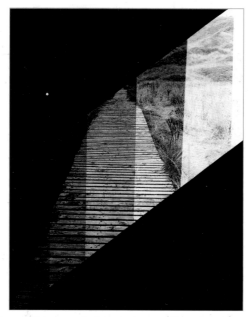

A test strip made with method 1 representing exposures of 5 to 25 seconds.

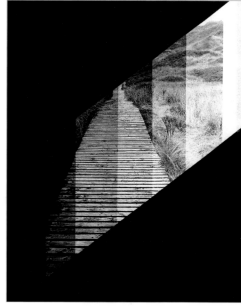

A test strip made with method 2 representing exposures of 5 to 30 seconds.

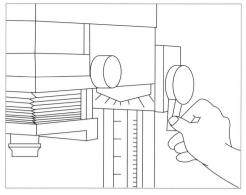

Adjust the height of the enlarger so that the light covers the size of paper that you are using with a little to spare. Focus the light so that the edges of the empty negative carrier are not soft and cause a darkening effect at the edges.

Making a Contact Sheet

A contact sheet provides negative-sized positive images, which can prove useful when deciding which negatives to print from a roll of film. It can save printing up inferior shots and is ideal when a reference is needed for the negatives. Some photographers will assess the negative directly and print from that information alone, but this requires familiarity with materials and an experienced eye.

Before making a test strip or a contact sheet it is important to check that developer, stop bath and fix are all at operating temperature (20 degrees C). The full processing sequence is explained in Making a Print, overleaf.

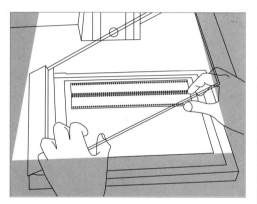

Place the negatives on the paper and cover them with a sheet of clean glass or use a contact printing frame. As this must be done with available light from the safelight, which is often not bright enough to allow accurate positioning, use the red filter on your enlarger and position the negatives under the red light.

Expose the contact sheet for the desired time and proceed with normal development. A test strip as outlined earlier helps to give an indication of the correct exposure time.

Julien Busselle

Print: The Boardwalk

This boardwalk leads to one of my favourite photographic locations on the North Devon coast. To capture and enhance the perspective effect I used a wide-angle lens and focused only a few feet in front of me. This made the background slightly soft, eliminating unwanted detail in the distance.

Technical Details

6 x 4.5cm SLR camera with a 45mm lens; 1/30 second at f16. Kodak T-400 CN developed in C-41 chemistry.

Print Details

Ilford Multigrade IV fibre-based paper with a warm tone. Exposure time was 15 seconds at f8 with a contrast of grade 4. I used my diffuser enlarger with a variable-contrast head.

03. Making a Print

Make sure your negative is clean and free from dust. Place it in the negative carrier, positioning the image accurately in the window before closing the carrier. Place the carrier in the enlarger, making sure it is properly in position.

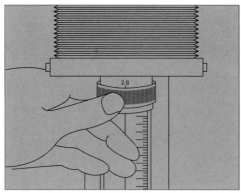

Switch off the main light – the rest of the procedure should be carried out under safelight conditions only. Open the enlarging lens to its widest aperture. This will give the brightest image, making focusing easier.

Set the masking frame (enlarging easel) to the size of paper that you are using, making an allowance for borders. With the enlarger light on, raise or lower the enlarger head so that the image is about the right size.

Focus the image, preferably using a focus finder which allows precise adjustment. You may have to readjust the size and refocus. Close the lens aperture two or three stops for maximum sharpness. Make a test strip (page 56 – 57) unless you know the correct exposure for the print.

After making the test strip set your enlarger timer and expose your paper. Slide the paper into the tray of developer. Rock the tray in a gentle motion for even coverage. Resin-coated papers will normally need 60 seconds development and fibre-based papers will need approximately 2 minutes.

After the development time, slide the paper into the stop bath and rock for a minimum of 10 seconds.

Slide the paper into the fix and rock gently, this time for 2–3 minutes for resin-coated papers or for 10 minutes for fibre-based papers. (These are general guidelines only so check these and the developer times with the instructions that come with the paper and chemicals.)

Finally, wash the print in running water. For resin-coated papers the wash is normally complete in 2–5 minutes; for fibre-based papers you may need to rinse for 60 minutes. The cooler the water temperature, the longer the wash time needed. Dry the prints in a dust-free environment.

Tip: Although a resin-coated paper will dry fairly quickly and flat, a fibre-based paper will take quite some time to dry properly. To counteract the curling effect of fibre-based paper, place two thoroughly wet prints back to back using pegs all round. Hang them up to dry. The effect of both sheets of paper together will reduce the curling.

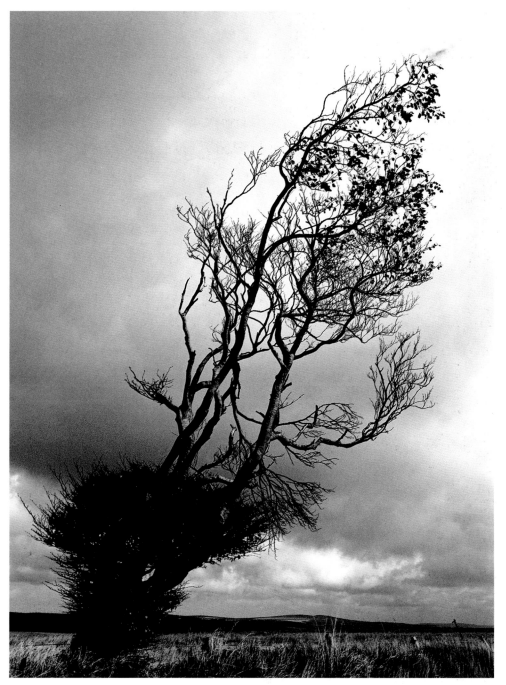

Julien Busselle

Print: Windswept Tree, Exmoor

This particular tree had been asking to be photographed for quite some time, but I had to wait for the right lighting. The tree could only be photographed from a small lane and to get the angle I wanted I used a 45mm lens from a rather cramped position.

Technical Details

6 x 4.5cm SLR camera with a 45mm lens; 1/15 second at f22. Ilford FP4+ developed in Infosol-S diluted 1 to 9 for 6 1/2 minutes.

Print Details

Ilford Multigrade IV resin-coated paper with a pearl finish. Exposure time was 24 seconds at f8 with a contrast of grade 3 1/2. I used my diffuser enlarger with a variable-contrast head.

04. Adjusting Exposure

The best way of assessing the exposure for a print is by using a test strip. Once a print has been made, you may like to make adjustments to the exposure in order to achieve the level of depth and detail that you require. The points below are universal regardless of subject.

This print was underexposed for 5 seconds to show the lack of detail in the sand and the weak shadows which don't have any depth. The print is washed out and the textures have no body to them.

Print: Weathered Groyne, Crow Point

I came across this groyne whilst intending to photograph the surf as it was flooding into the mouth of an estuary. In order to capture the sand and fishing line that had become trapped, I had to photograph the groyne from above. At first I used a macro lens to close in on this detail only, but I also wanted to capture the wood grain at the front. My solution was to use my wide-angle lens to capture the whole of the groyne and to exaggerate the perspective, giving the structure a tower-block feel. I was also testing a new film at the time and felt that the detail in the subject was a suitable challenge; normally for this subject matter I would use a very slow film and process in an acutance developer to maintain sharpness. The result was a surprise as the resolution was better than expected with an impressive tonal range.

Technical Details

6 x 4.5cm SLR camera with a 45mm lens; 1/60 second at f22. The film was Kodak T400 CN, a chromogenic film, processed in C-41 chemicals.

Print Details

Ilford Multigrade IV fibre paper with my preferred warm-tone base exposed for 20 seconds at f8 with a contrast of grade 4. I used my diffuser enlarger with a variable-contrast head.

I overexposed this print to show the effect that this has upon shadow detail. Put simply, it is not there any more. The highlights have sunk into the image as well, but it is shadow detail which is the guiding factor here.

Julien Busselle

My exposure for this print was 20 seconds at f8. This is my optimum exposure for this image. There were no true white highlights in the shot; the fishing line was the lightest part of the image. The sand needed to be correctly exposed to retain its texture – all the detail was essential for this to happen, it would have been lost had a lighter exposure been given. I also wanted to pull out all the detail within the wood grain, so it was equally vital to give enough exposure to ensure that the shadow areas of the print revealed all their information as well.

05. Adjusting Contrast

Adjusting contrast is a very personal part of printing – ideally a full range of tones should be present and the level should match the original scene. It is very common to print hard all the time in the early stages. High contrast is eye-catching but you should aim to print a wide variety of levels as the subtlety of some scenes is lost when contrast is even marginally too high. Too low a level of contrast, on the other hand, always leaves prints somewhat lifeless, with little impact.

Julien Busselle

My preferred level of contrast for this print is grade 3.5. The scene was already quite subtle when it was taken, with the wide range of mid tones I wanted to capture. At this level of contrast the print appears very smooth and the detail on the headland shows good gradation. This is exactly how I wanted it to appear – velvety smooth.

Look at shadow and highlight detail to assess contrast. In this scene looking at the areas on the headland gave me the answers: being an overcast day the shadows were only truly dense in very deep fissures within the rock face and the lack of light reflected from the rocks placed them in a high value grey as opposed to a low value white. If in any doubt print the scene how you visualised it at the time, regardless of whether it is technically correct or not. Photography and printing are more emotion than science.

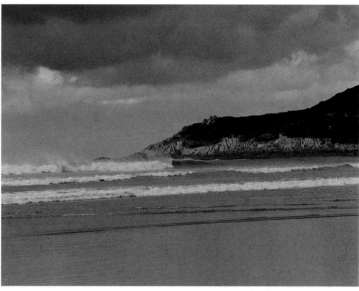

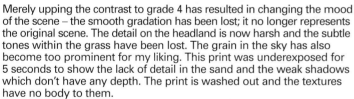

Merely upping the contrast to grade 4 has resulted in changing the mood of the scene – the smooth gradation has been lost; it no longer represents the original scene. The detail on the headland is now harsh and the subtle tones within the grass have been lost. The grain in the sky has also become too prominent for my liking. This print was underexposed for 5 seconds to show the lack of detail in the sand and the weak shadows which don't have any depth. The print is washed out and the textures have no body to them.

At grade 2 the scene has now become very 'muddy' in appearance, the whole scene giving the impression of being very flat and lifeless. There is not enough separation between tones and equally there are no low or high values.

Print: Morte Point, UK

This scene was taken at one of my favourite locations. On this particular day the lighting was very subtle and the range of mid tones gave the impression of smoothness to the whole scene. I used Ilford's XP2; in this case the ISO 400 speed helped capture the waves, but my main concern was to record those mid tones accurately. XP2 is one of the best films for recording these and its fine grain has helped keep the image very clean and velvety.

Technical Details

6 x 4.5cm SLR camera with an 80mm lens; 1/60 second at f22. Ilford XP2 film, processed in standard C-41 chemistry.

Print Details

The print was made on my preferred paper – Ilford Multigrade IV FB warm tone. An exposure of 30 seconds at f8 was given and the print was processed in Multigrade developer. I used my diffuser enlarger with a variable-contrast head.

Print: Timeless

The intention of this image by Michael Miller was to create a mood that not only had broad appeal, but that also stood the test of time.

Technical Details

35mm SLR camera with an 85mm lens; 1/250 second at f2.8. Kodak T-Max 400 developed in Kodak HC 110.

Print Details

The print was made on Ilford Multigrade IV resin-coated paper with a pearl finish. The enlarger was a diffuser type. An exposure of 20 seconds at f8 was given with a filtration factor of 3. The print was processed in Ilford Multigrade developer diluted 1 to 9 for 60 seconds.

Print: Serenity

The object in this print by Michael Miller was to achieve a spatial balance to create an air of calmness and solitude. The deserted beach and cloud formation in the background help to create this harmonious effect.

Technical Details

6 x 7cm SLR camera with a 50mm lens; 1/60 second at f11. Agfapan APX-100 developed in Agfa Rodinal diluted at 1 to 25 for 8 minutes. A red filter was used to enhance the contrast.

Print Details

The print was also made on Ilford Multigrade IV resin-coated paper with a pearl finish. Michael used a diffuser enlarger and a filtration factor to give a contrast level of grade 4. The print was exposed for 45 seconds at f8 and was processed in Ilford Multigrade developer diluted 1 to 9 for 60 seconds.

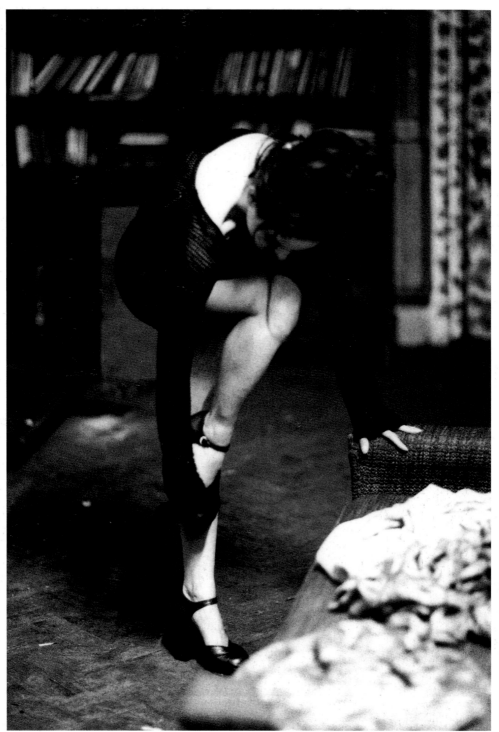

Michael Miller

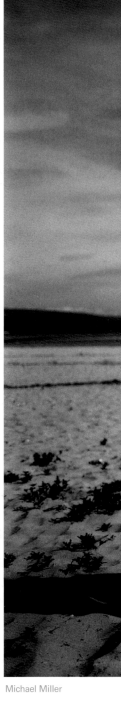

Michael Miller

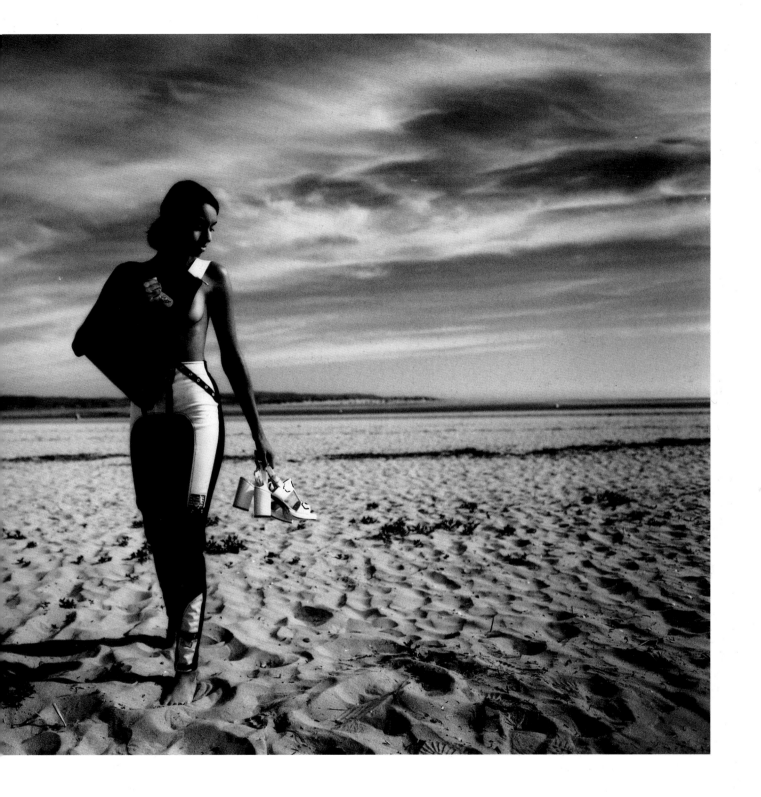

Dodging and Burning in

One of the great pleasures of printing your own photographs is having total control over the finished image and adding your personal touch to fine-tune a print. An effective way of controlling the image is to alter an area of the print selectively by increasing or decreasing exposure. Known by the distinctly un-technical terms of dodging (reducing exposure) and burning in (increasing exposure) these simple techniques can bring you one step closer to achieving a better print.

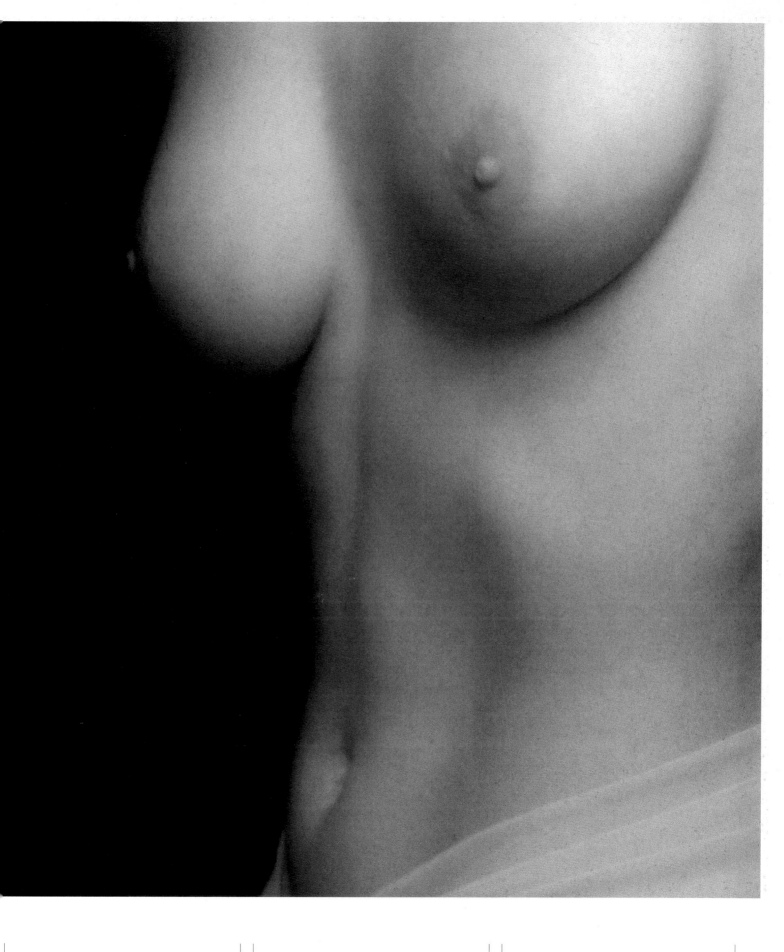

Dodging and Burning in

Dodging

This technique is used to lighten an area of a print by shading it during the main exposure. What you are doing is effectively reducing the amount of light received by one particular area, whilst the surrounding area receives the full exposure. Although using your hand is fine for sections of the print that aren't too fiddly, a dodging tool is vital for areas that require a more precise approach. There are tools available ready-made but you can easily make your own using fine but stiff wire and some cardboard which can be cut to suit the shape intended for shading. By taping these shapes to the wire, you can shade difficult areas. You can also use plasticine instead of card for particularly tricky shapes. Different lengths of wire aid control and keep fingers well clear of the image.

Tip: Whether dodging or burning in, using your hand or a tool, it is vital to introduce movement so any transition of tone will be softened and become unnoticeable. Record dodging and burning in times by drawing a diagram of the image and logging them accordingly. This is invaluable for creating the desired effect and being able to repeat it.

Burning in

Also known as printing-in, this is basically dodging in reverse. To selectively darken an area of a print you give additional exposure to this part of the picture whilst shading the rest. This technique is commonly used to correct skies which have become washed out or to simply enhance a moody sky in a landscape. Although burning in can be achieved by shading your main exposure with your hand whilst giving additional exposure to the unshaded area, more accurate shading can be done by cutting an appropriate shape or hole in a piece of card, thus avoiding the need for all manner of contortions. Whatever you choose to use make sure you keep it moving to ensure that there is no hard edge produced between the shaded and unshaded areas of the print.

Applying the technique

Prints that require a substantial amount of shading are normally obvious, but it often pays to apply subtle shading techniques to an image if it differs from your original concept. Extracting more detail from the shadows is a very common use of dodging and darkening a sky is one of the most frequent uses of burning in. Techniques such as these can lead one step closer to the image originally visualised, the smallest differences often leading to the most satisfying results. It is worth mentioning that any shading should not be a substitute for a correctly exposed and developed image; a natural, straight print will be preferable to an overworked one. Most photographers go to great lengths to achieve a perfect negative that requires nothing other than a straight exposure. However, life is rarely that simple and these additional techniques will be needed. Use them to enhance an image and not simply because you feel obliged to.

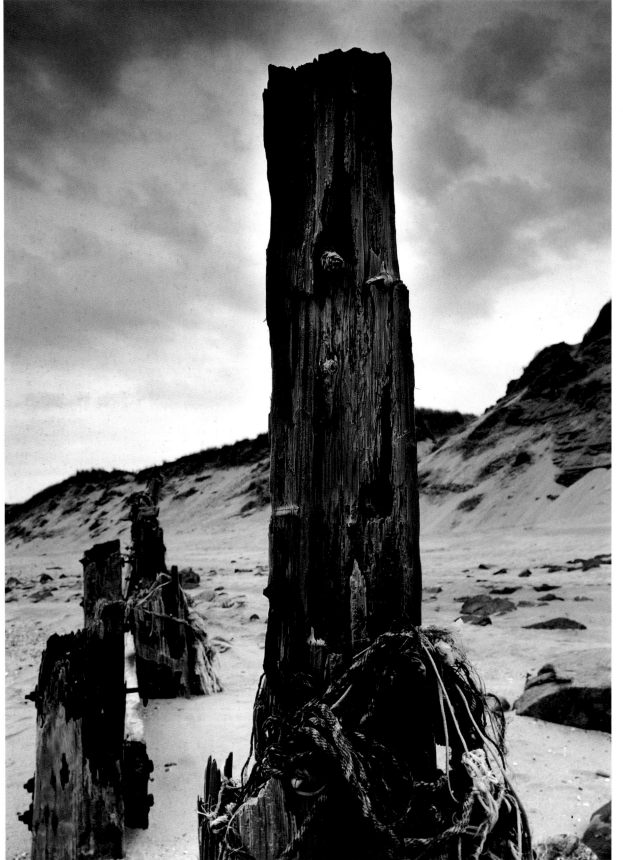

Julien Busselle

Print: Weathered Groyne

This was shot to demonstrate both shading techniques. I had only seconds to set up and make the exposure; the tide was lapping at my boots and one exposure was all I got. I already knew that the sky and the detail in the groyne would require burning in and dodging in order to produce an acceptable image.

Technical Details

6 x 4.5 SLR camera; 55mm lens; 1/30 second at f16. Ilford XP2 developed in standard C-41 chemistry.

Print Details

Ilford Multigrade IV in pearl finish; 60 seconds in Multigrade developer diluted 1 to 9. The enlarger was a diffuser type with a colour head.

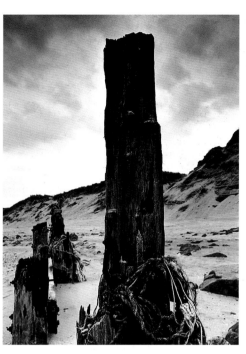

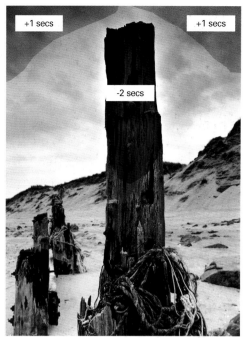

My first print was made with the aim of bringing forward detail in the groyne. I gave an exposure of 4 seconds at f5.6 and used the colour filters to give a contrast of grade 4. I felt that the foreground and detail in the groyne should be darker by two seconds but that the top section of the groyne needed around two seconds less exposure.

This print was made to determine the exposure for the sky. An overall exposure of 8 seconds was given.

An exposure of 6 seconds was given overall, during which I dodged the top section of the groyne for 2 seconds to bring out the interior detail. I also shaded the top corners of the sky for a second only to prevent them becoming too dominant. Finally, with the groyne and foreground exposed I burned in all of the sky for an additional 3 seconds, preventing any light from reaching the rest of the print with a shaped piece of card. The result was a more balanced image that has far more impact than the original print.

Tip: It is always a good idea to allow the first print to dry thoroughly before making a final one. This is because a print will often go slightly darker – perhaps as much as 10 per cent – as it dries, although all papers act slightly differently in this respect. It is especially important to carry out this check when using a paper for a long time, and once you're used to the way it reacts you'll be able to produce your prints accordingly.

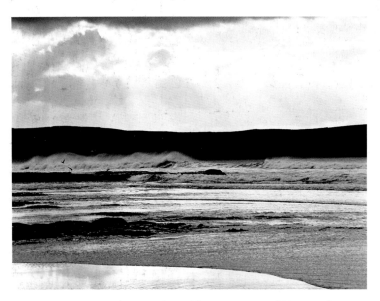

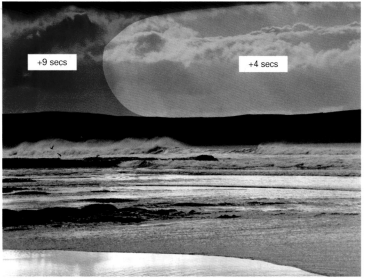

+9 secs

+4 secs

My first print was made at grade 4 with an exposure of 30 seconds at f8. The level of contrast is right for me, but I need to give additional exposure to the sky. Due to the difficult lighting in the shot this was to be expected.

My final print was made at grade 4, reducing the overall exposure to 26 seconds – just enough to 'lift' the foreground slightly, especially the birds and the wave spray. I then gave an additional exposure of 9 seconds to the sky only and another 4 seconds to the right-hand side of the sky. The finished print was how I saw the photograph originally, dramatic but peaceful. I managed to capture the spray of the waves, but special thanks must go to the seagulls for being in the right place at the right time!

Julien Busselle

Print: Atlantic Swell

This shot was taken on a storm beach as the surf relentlessly pursued me and my camera gear up the beach. The picture was taken on Ilford XP2 used because of its speed which helped to capture the breaking waves and because of its fine grain. The shot was timed to capture a wave as it began to curl; the birds taking off on the left-hand side were a bonus, luckily for me – I think they make the picture.

Technical Details

6 x 4.5cm SLR; 80mm lens; 1/60 second at f22. Ilford XP2 in C-41 chemistry.

Print Details

Ilford Multigrade fibre-based paper with a warm-tone base. Two minutes in Multigrade developer diluted at 1 to 9. Diffuser enlarger with a variable contrast head.

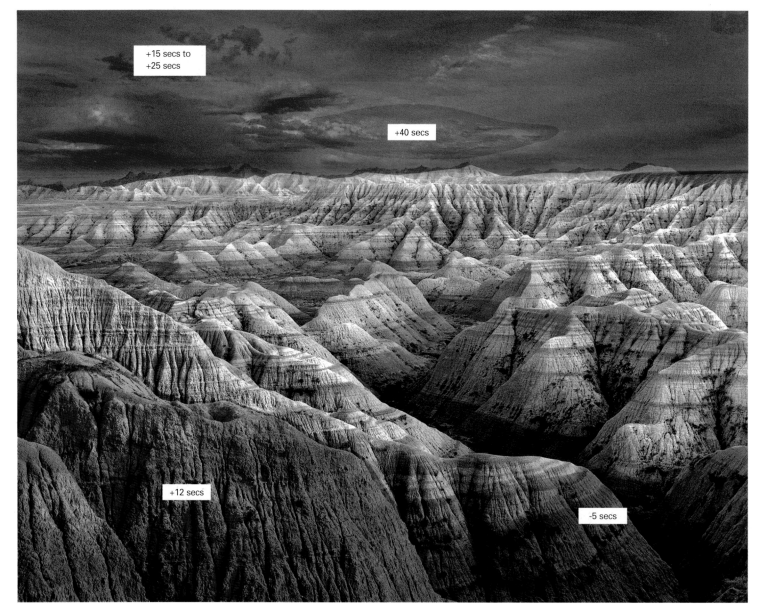

Print: The Badlands, South Dakota, USA

Tony Worobiec took this shot on his very first visit to an American National Park, and was overawed by the sheer natural majesty of the place. As a European, he was unaccustomed to seeing a view so totally devoid of soil and vegetation. He felt it was almost as if he were viewing a skeletal landscape. Despite the dramatic sky, he was in no hurry to take this picture as he was very concerned about choosing a viewpoint which most eloquently described the rhythms of the landscape.

Technical Details

6 x 4.5cm SLR; 90mm lens; 1/60 second at f22 with a light orange filter. T-Max 400 rated at 800 ASA developed in T-Max developer for 20% longer than is normally recommended for this film.

Print Details

Illford Multigrade IV glossy paper developed for 1 1/2 minutes in Ilford Bromaphen paper developer diluted 1 to 4. The enlarger was a condenser type. Tony gave the print an overall exposure of 18 seconds at f8 on grade 4 paper although he held back the shadowed area in the bottom right for 5 seconds in order to retain the recurring rhythm throughout the print. To balance this, he burned in the ridge of rock in the bottom left for a further 12 seconds. The sky also needed extra exposure, burning in from 15 seconds to 25 seconds from left to right. Finally, using a piece of card with a small hole in it, he burned in the strong area of highlight in the middle of the sky for an extra forty seconds, taking great care to keep the card moving.

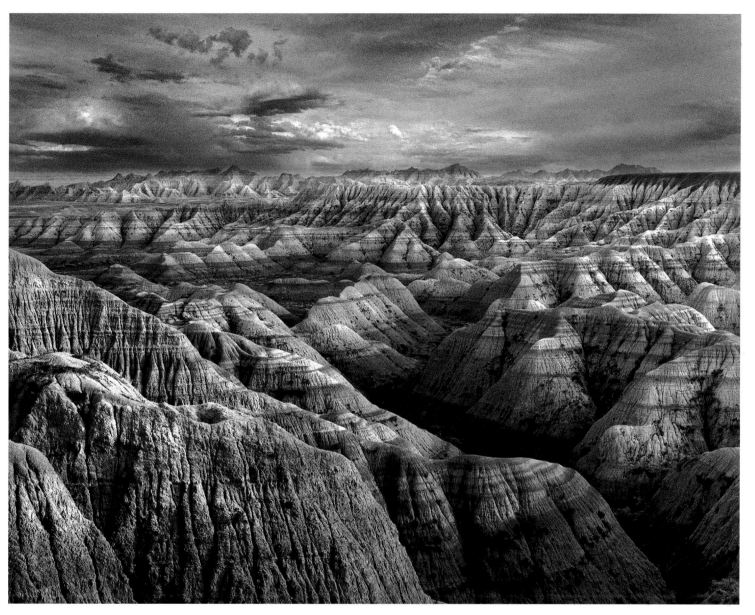

Tony Worobiec

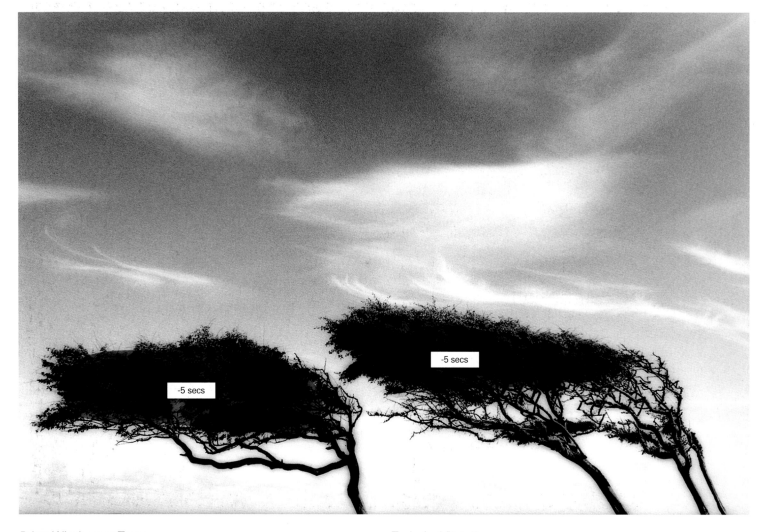

Print: Windswept Trees

Finding these trees on downland, Michael Milton was immediately struck by their texture and contorted shape. The addition of the wispy clouds blended with the trees to give a suggestion of the power of the wind.

Technical Details

35mm SLR camera; 28mm lens; 1/60 second at f16. Kodak Tri-X ISO 400 developed in Ilford Ilfosol-S at a dilution of 1 to 9 for 10 1/2 minutes.

Print Details

Agfa's Record Rapid fibre-based paper grade 2 developed for 2 minutes in Agfa Neutol diluted at 1 to 4. The enlarger was a condenser type. The overall exposure was for 12 seconds at f8 with the foliage of the trees held back for 5 seconds of this with a home-made dodging tool. The finished print was selenium toned at a dilution of 1 to 19 for 15 minutes.

Michael Milton

Print: Careful Descent, Ötztal Alps, Austria

Dave Butcher took this right at the start of a ski mountaineering trip in the Ötztal Alps, Austria. Wearing their skis, the group abseiled down an ice and snow covered cliff until the slope eased and the rope ran out. They side-stepped the rest of the way down to the glacier. Dave went first because he was hoping for a dramatic shot looking back. He metered off his outstretched gloved hand using the centre-weighted meter in the camera. Then he locked the exposure and recomposed the picture. There was time for just two shots before a hail of flying ice being kicked down from above made him beat a hasty retreat. The orange filter darkened the sky and the small aperture of f22 produced the starburst effect.

Technical Details

6 x 6cm Rangefinder; 50mm lens at f22 with an orange filter. Ilford 100 Delta 120, ISO 100 developed in Ilford ID11 stock for 6 1/2 minutes.

Print Details

Ilford Multigrade IV RC glossy paper developed in Ilford Multigrade diluted at 1 to 9 for 60 seconds. The diffuse enlarger has a colour head. In the darkroom, Dave compensated for the darkened shadows created by the use of the orange filter by dodging the skier for 4 seconds and the rock on the left for 3 seconds. The bottom corners were both held back to add some extra brightness to the print, and he darkened the sky and the sun to emphasise the starburst.

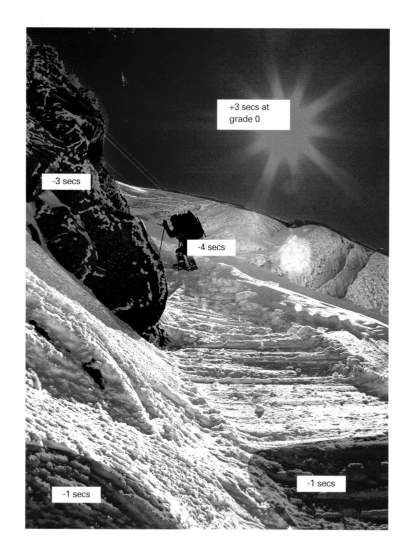

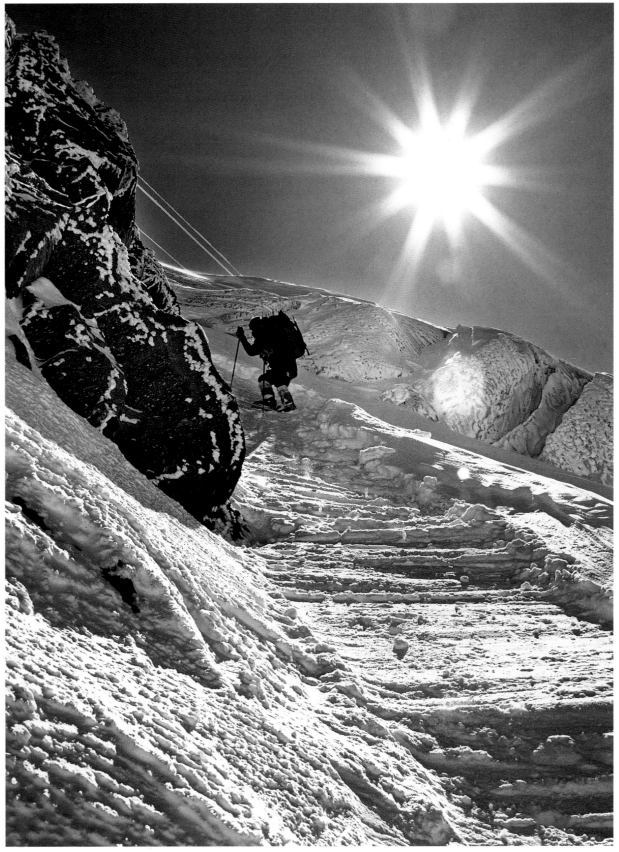

Dave Butcher

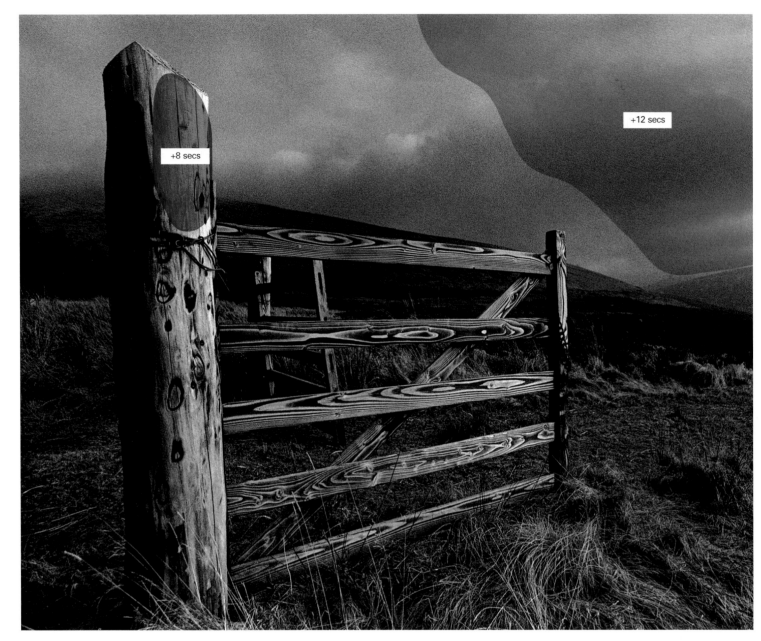

+8 secs

+12 secs

Print: The Gate

This shot was taken in December to highlight winter light by Seán Kennedy. Seán finds that some of his best landscape pictures are taken during the winter months. He was travelling in the Wicklow mountains with friends in Eire when he saw this gate stranded in a field with no fence on either side. It was treated with some sort of wood preservative and he used a red filter to highlight the grain in the wood.

Technical Details

35mm SLR camera; 19mm lens with a red filter. Ilford Delta 400 developed in Kodak D76 diluted at 1 to 1 for 10 minutes.

Print Details

Ilford Multigrade IV gloss paper developed in Multigrade developer diluted at 1 to 9 for 60 seconds. (For club work and most competitions Seán uses resin-coated paper, but for exhibitions he uses fibre-based Agfa Classic.) The enlarger is a condenser type. An overall exposure of 15 seconds was given to this print with a grade 4 filter, but Seán burned in the top-right corner for an extra 12 seconds to balance the sky and he gave an extra 8 seconds to the top of the near post.

Seán Kennedy

-5 secs

+5 secs

Print: Nick Cave

This was taken by Matt Anker during a hectic studio session during which he chose to light the face with a single powerful flash. Matt used a bare light source to create a hard image with great intensity. The single light source also added a very strong highlight in the eye, creating an immediate focal point. This style of image is something he sets out to achieve with male musicians, giving a sense of 'climbing into the pores', as if the viewer is having a close conversation with the subject.

Technical Details

6 x 6cm SLR camera with a 120mm lens; 1/500 second at f8. Kodak T-Max 100 developed for 6 1/2 minutes in T-Max developer diluted 1 to 7 at a temperature of 24 degrees C.

Print Details

The print was made on Ilford Multigrade IV resin-coated paper. Matt used a diffuser enlarger with a variable-contrast head. Due to the hard image he used a grade of 2 1/2. The overall exposure was 35 seconds during which he held back the eye with a dodging tool for 5 seconds to keep detail in this area and to maintain the highlight. He gave an additional 5 seconds exposure to the edge of the jaw bone and neck area to keep the light level down a little in this particular area. He used Agfa Neutol WA print developer as its slightly warming effect is particularly good with skin tones.

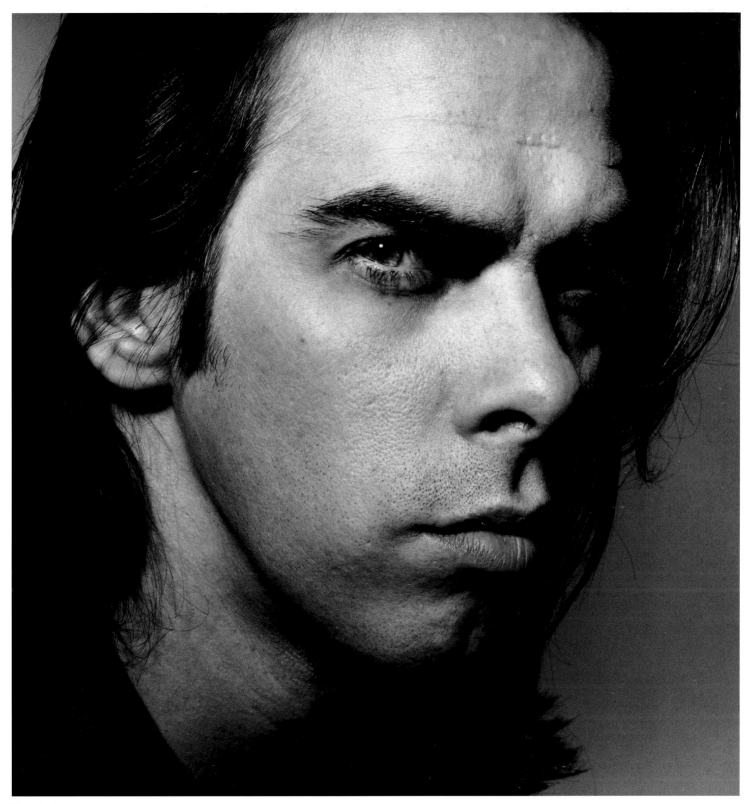

Matt Anker

Section 6
Practical Techniques

The following prints are broken down with their details and the photographer's personal viewpoint. The idea behind this is not just to inspire but to create a more intimate feeling for the images; more of a 'how it was done' rather than a 'now you do this' scenario. This method of presentation seemed the most natural and clear way of demonstrating the craft of these photographers.

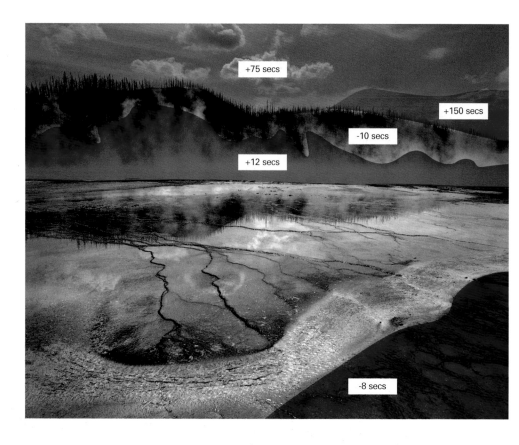

The photo contains the following annotations: +75 secs, +150 secs, -10 secs, +12 secs, -8 secs

Tony Worobiec

Print: Geyser; Yellowstone Park, USA

Geysers generally look far more dramatic photographed in winter when the hot steam vapourises in the cold winter air. However, I was here in summer so I needed to contrast the white plumes of steam against a dark background. This was provided by the distant hill. I was also drawn to the wet strata and the glistening steam flowing in from the bottom left of the composition. The weather was generally sunny, but with so much reflection around I waited until the sun disappeared behind a cloud. Even though the lighting conditions were good, the slow speed of the film called for the use of a tripod.

Technical Details

6 x 7cm SLR; 45mm lens; 1 second at f22. Agfapan 25 rated at ISO16 ASA developed in Ilford ID11 at a dilution of 1 to 1 for 8 minutes. I used an orange filter to maintain detail in the sky.

Print Details

Ilford Multigrade IV gloss paper developed for 1 1/2 minutes in Multigrade developer diluted 1 to 9. The enlarger has a condenser head. As I wanted to emphasise the dramatic lighting qualities of this image, I used a relatively hard grade of paper (grade 4). I gave this an overall exposure of 36 seconds, but held back the dark distant hills for 10 seconds and the bottom right-hand corner for 8 seconds while giving the steam rising from the geyser an extra 12 seconds to ensure it stood out against its background. I burned in the sky for a further 1 1/4 minutes but the light area immediately above the horizon on the right-hand side was burned in for up to 2 1/2 minutes.

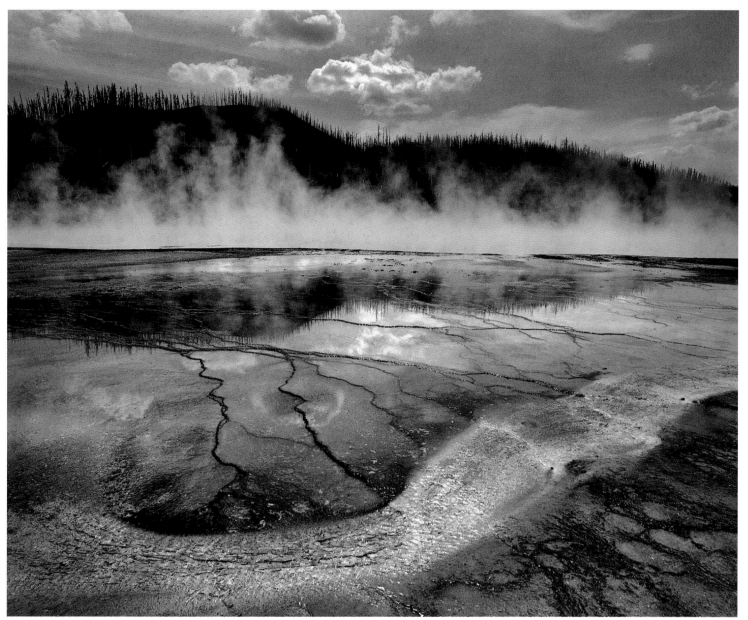

Tony Worobiec

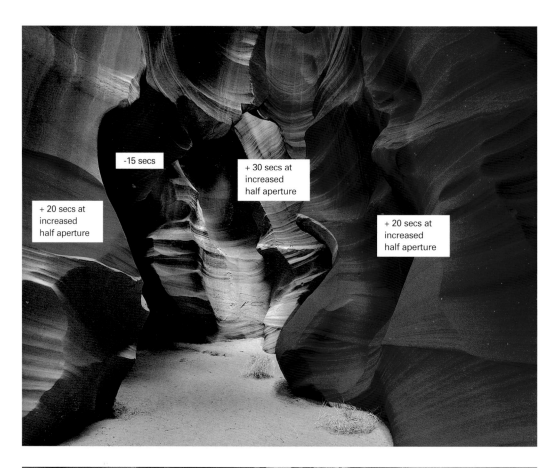

+ 20 secs at increased half aperture

-15 secs

+ 30 secs at increased half aperture

+ 20 secs at increased half aperture

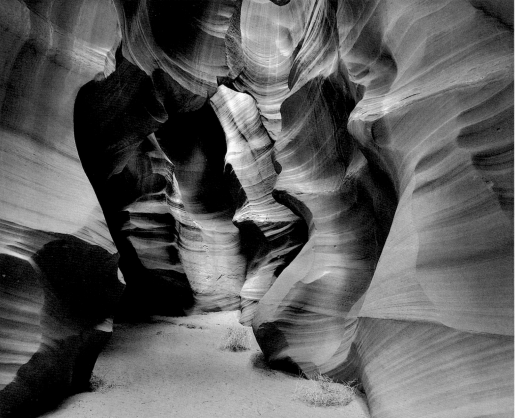

Tony Worobiec

Tip: A 2-bath film developer, such as Tetenal's Emofin, is very useful in conditions of high contrast. Highlights are held back while shadows continue to build.

Tony Worobiec

Print: Antelope Canyon, Utah, USA

This particular slot canyon is located about three miles from the nearest road, so it required a fairly tricky hike through the desert to get here. However, it was worth it. Fortunately, it was early April and there were virtually no other photographers around, so really I had the place to myself. I was immediately drawn to the natural rhythms of the rock and the wonderful interplay between the light and dark areas. The two pieces of tumbleweed helped to introduce a sense of scale. What did surprise me was how dark these places are and how much contrast there is. I was eager to maintain both highlight and shadow detail, therefore I exposed for the shadows but cut back on the highlights at the development stage.

Technical Details

6 x 7cm SLR; 45mm lens; 3 minutes at f22. Kodak T-Max developed in Tetenal's Emofin (a two-bath film developer).

Print Details

Ilford Multigrade IV gloss paper developed for 90 seconds in Multigrade developer diluted 1 to 9. The enlarger has a condenser head. An overall exposure of 35 seconds on grade 1 1/2 was given to the print, although the darker area to the left of centre was dodged for 15 seconds. I opened my aperture by half a stop and burned in the large area of rock to the right of the picture and the lighter area to the extreme left for 20 seconds. Then, by using a piece of card with a small aperture cut into it, I carefully 'painted' an extra 30 secs of light into the 'funnel' in the top centre of the picture.

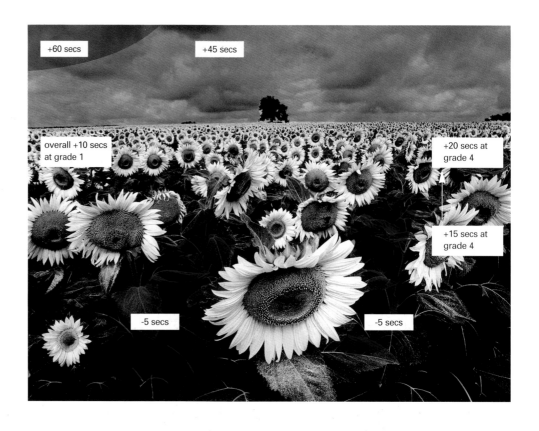

Tip: Split grading is used on a print that requires a varying degree of contrast in different areas of the print. For instance, a sky may need a higher level of contrast than you would wish for the foreground; by using a variable contrast paper and exposing it with different filter grades, a print can be made that allows the contrast range to cover both.

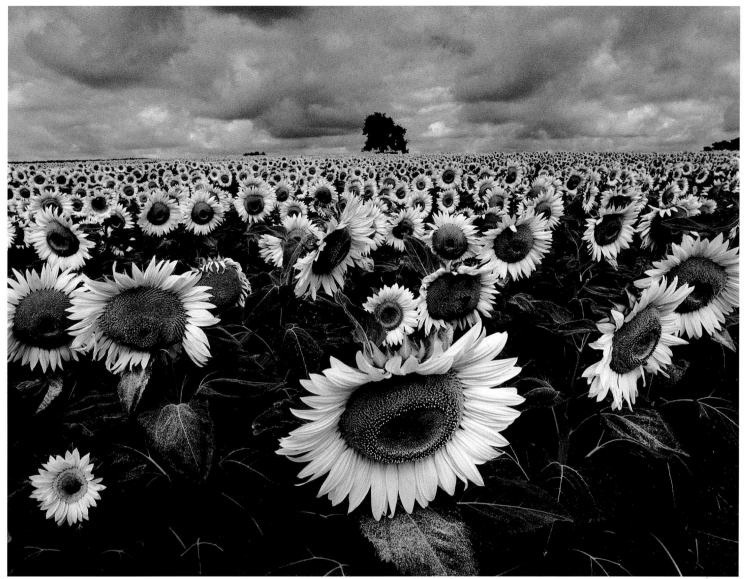

Tony Worobiec

Tony Worobiec

Print: Field of Sunflowers

As photographers we can sometimes get conditioned into seeing certain subjects only in one way. The strong and dramatic yellows which characterise fields of sunflowers scream out to be photographed in colour, and yet strangely enough this subject can work equally well in black and white. In this situation, a colour interpretation will undoubtedly appeal to the emotions of the viewer. However, when presented in monochrome the graphic qualities of this scene become much more apparent.

Technical Details

6 x 4.5cm SLR; 35mm lens; 1/125 second at f22 with an orange filter. Ilford HP5 developed in Ilford ID11 diluted 1 to 1 for 14 minutes.

Print Details

This is a classic example of where split-grading can be useful. Even though this shot was taken on a moderately overcast day, I needed to use an orange filter to get the drama I required from the sky. This also had the effect of darkening the leaves whilst lightening the sunflowers. I gave this print an overall exposure of 15 seconds, burning in for up to 20 seconds from the bottom of the image up to the horizon, but holding back the dark recesses on either side of the largest bloom. This part of the exposure was done on grade 4. The sky was burned in for a further 45 seconds, although the top and left were increased to 1 minute. I then changed to a grade 1 filter and burned in the entire print for a further 10 seconds in order to put in some of the delicate highlight detail which had been lost as a consequence of using grade 4 for the main exposure.

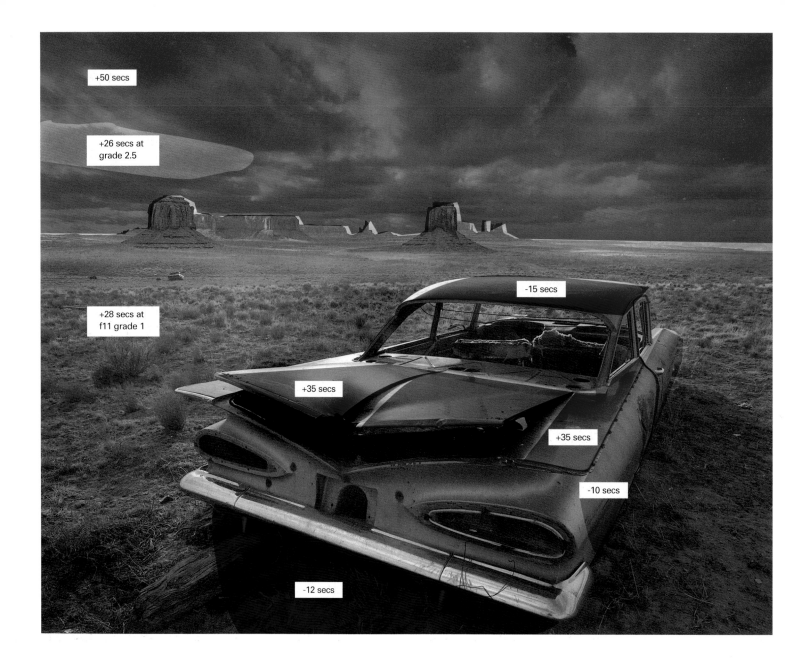

Tony Worobiec

Print: Wreck near Monument Valley, USA

I had always imagined that Monument Valley was a national park and was surprised to discover that it was land owned by the Navaho Indians. Whilst the valley itself has been wonderfully preserved, adjacent areas have numerous small settlements with the inevitable abandoned cars. This one I spotted about 1/2 mile from the road so I climbed a fence and made my way over to it. I view this image slightly romantically; the car is a potent symbol of freedom which is emphasised within the context of this dramatic landscape.

Technical Details

6 x 7cm SLR; 45mm lens; 1/125 second at f22. Kodak T-Max 400 developed in Kodak T-Max developer. I used a red filter to dramatise the sky.

Print Details

Ilford Multigrade IV gloss paper developed for 1 1/2 minutes in Multigrade developer diluted 1 to 9. The enlarger has a condenser head. This photograph was taken late in the afternoon. The contrast on the car was clearly going to create problems at the printing stage, so I decided to split-grade. I used grade 1 to print in most of the negative in order to make the fierce contrast on the car more printable, but then chose to print in the sky using grade 2 1/2. I gave an overall exposure of 28 seconds at f11 on grade 1, and gently held back the sky. During this first exposure, I needed to dodge the shadowed areas around the car for between 10 and 15 seconds but I was then required to burn in the highlights on the boot and on the right-hand side of the car. I then changed to a grade 2 1/2 filter and gave the sky an exposure of 26 seconds at f8, burning in selected areas for up to 50 seconds.

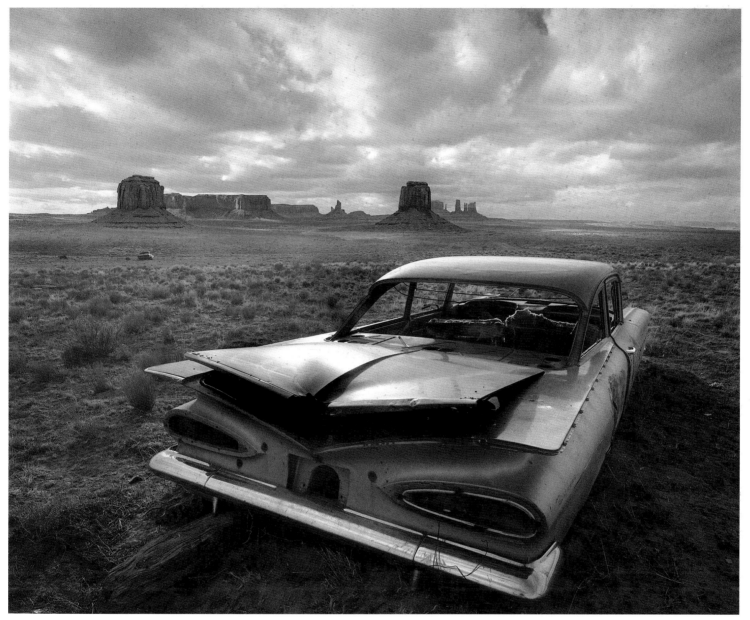

Tony Worobiec

Dave Butcher

Print: Maroon Bells Reflection

I was already set up with my tripod taking pictures of this spectacular scene in the Colorado Rockies near Aspen, USA, when the light breeze that was rippling the surface of the lake dropped and the reflection appeared. I took shots for about 10 minutes before the breeze returned and the reflection was gone. This one, taken with a standard lens, was more impressive than the ones I took with a wide-angle lens in which the expanse of dark trees overpowered and unbalanced the prints.

Technical Details

6 x 6cm Rangefinder; 75mm lens; aperture of f16. Ilford FP4+ 220, ISO 100 developed in Ilford's Ilfosol-S diluted at 1 to 9 for 6 1/4 minutes.

Print Details

Ilford Multigrade IV RC pearl paper developed in Ilford Multigrade diluted at 1 to 9 for 60 seconds. The diffuse enlarger has a colour head. I printed this shot to show the grandeur as well as the detail and subtle tones in the landscape. On the straight print there was very little density above the tree line so most of this came from additional exposures. The basic exposure was for 10 seconds at f8 using grade 2 1/2, although I gave the trees at centre left 2 seconds less. The area above the trees was given an additional 30 seconds and the sky and mountain top an extra 10 seconds, while the mountain reflection had an extra 5 seconds. Care is needed when doing so much burning in to avoid it showing and I used a U-shaped piece of card held high under the enlarger to do this. Also, without a lot of care the trees on the left could have gone completely black.

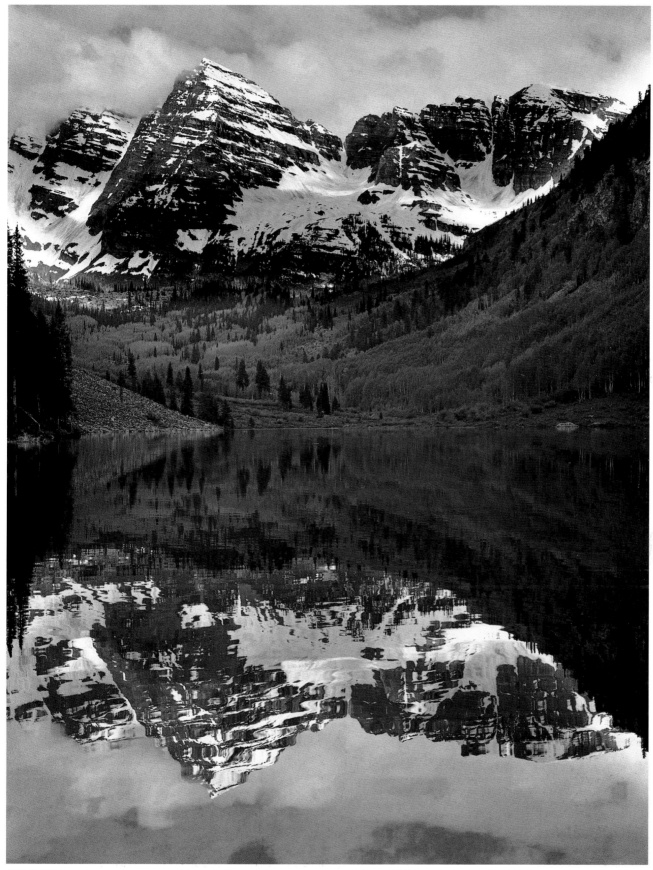

Dave Butcher

Dave Butcher

Print: High Mountain Shrine and the Breithorn, Switzerland

I saw the clouds building up while I was right at the top of the Zermatt ski area but below a point at which I could get to the viewpoint I wanted, having seen the shot earlier in the day. It took me almost an hour to ski down, queue for the lift and reach the viewing platform above the Klein Matterhorn cable car station. The sky was now even more dramatic. It was not possible to reach the ideal viewpoint because of the safety barriers, so I knew I would have to make some adjustments in the darkroom to give the print the impact I wanted. I was just a few feet from the cross so I used a small aperture to give the depth of field required so that both the cross and mountains would be in focus.

Technical Details

6 x 6cm Rangefinder; 50mm lens; aperture of f22 with an orange filter. Ilford FP4+ 120, ISO 100 developed in Ilford's ID11 diluted at 1 to 1 for 8 1/4 minutes.

Print Details

Ilford Multigrade IV RC glossy paper developed in Ilford Multigrade diluted at 1 to 9 for 60 seconds. The diffuse enlarger has a colour head. A guard rail cut across the bottom of this negative and I wanted to exclude this completely. To make the print more dynamic I placed the diagonal of the cross in the top-left corner. Faces are always a focus in photos so I lightened this area of the print for emphasis. I used a basic exposure of 8 seconds at f8 using grade 4 with 3 seconds less for the head and 2 seconds less for the black rocks below the summit. I also used 1 second less on the shadow on the vertical of the cross. Finally I burned in the snowy peaks in the bottom-left corner for 5 seconds to give this area more detail.

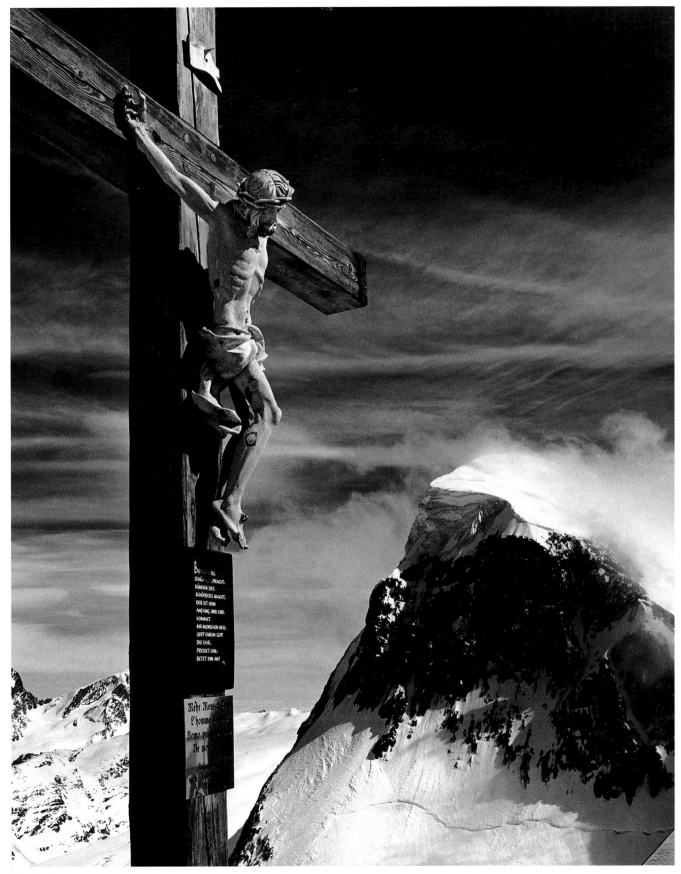

Dave Butcher

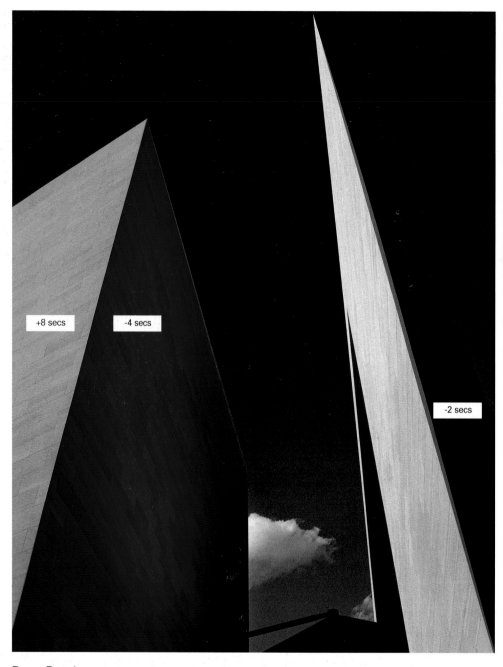

+8 secs -4 secs -2 secs

Dave Butcher

Print: Washington Art Gallery

My aim here was to make a print as striking as the structures themselves. To do this I wanted quite a graphic image of the buildings against a darkened sky. An orange filter helped produce this effect during the camera exposure.

Technical Details

6 x 4.5cm SLR; 45mm lens; aperture of f16 with an orange filter. Ilford HP5+ 120, ISO 400 developed in Ilford's Ilfotec LC29 diluted at 1 to 9 for 3 1/2 minutes.

Print Details

Ilford Multigrade IV RC glossy paper developed in Ilford Multigrade diluted at 1 to 9 for 60 seconds. The diffuse enlarger has a colour head. In the darkroom there were two basic areas to consider once the composition was decided. The building on the right tended to merge with the sky on the shady side, so I lightened this area just enough to separate them. On the other hand, the brightly lit brickwork on the left-hand building lost detail, so I burned this in. Using softer than grade 3 to simplify the dodging and burning would have reduced the print's punch so the extra work was necessary. During a basic exposure of 18 seconds at f8 using grade 3, I gave the right side of the right-hand building 2 seconds less exposure and the shady wall of the left-hand building 4 seconds less exposure. Then I gave the sunlit part of the building on the left an extra 8 seconds exposure to add in some detail.

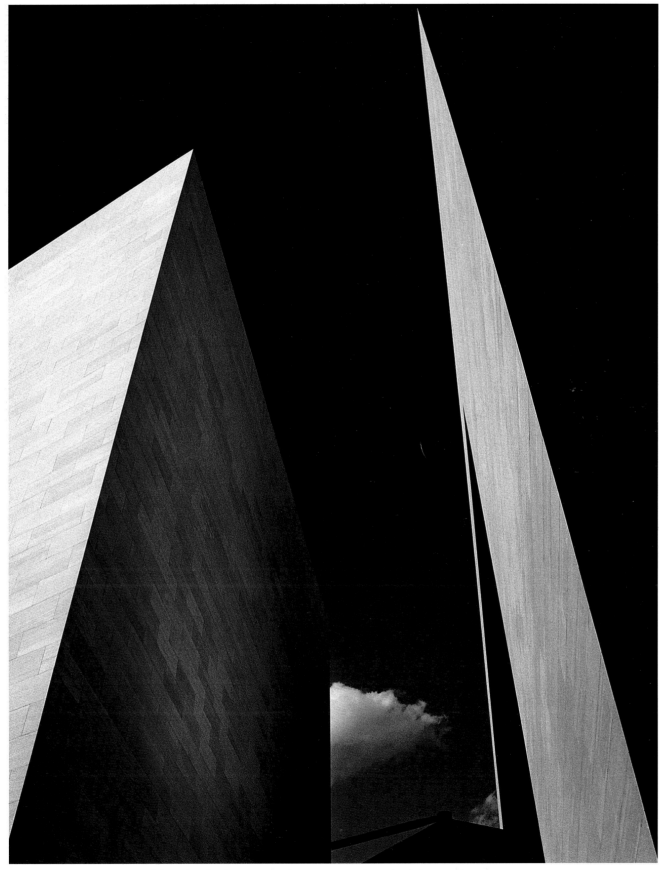

Dave Butcher

Dave Butcher

Print: Sunrise Ski, Bernese Oberland

This was taken on the last day of a tiring ski mountaineering trip to the area just south of the Eiger in Switzerland. We had been skiing for almost two hours, mostly uphill, when I took this shot at about 8am. I had just stopped to change film and could see the sun rising above the horizon and the long shadows from the skiers moving away from me. I knew this was the shot of the day. I almost ran uphill on my skis (not easy at 10,000 feet carrying a 25lb rucksack) so I could catch the moment before it vanished. With the camera I metered off the snow in shadow to the right and locked the exposure. I waited to compose the picture so there was a good separation of the skiers and only took one frame, although this was enough. The starburst effect was produced by the small f22 aperture.

Technical Details

6 x 6cm Rangefinder; 50mm lens; aperture of f22 with an orange filter. Ilford HP5+ 220, ISO 400 developed in Ilford Ilfotec HC1 diluted at 1 to 15 for 3 1/2 minutes.

Print Details

Ilford Multigrade IV RC glossy paper developed in Ilford Multigrade diluted at 1 to 9 for 60 seconds. The diffuse enlarger has a colour head. I wanted some detail in the closest skiers and for this I used small dodgers in each hand held high under the enlarger lens. I lightened the foreground snow to brighten the print and dodged the rocky outcrop to retain some detail in the shadows and to allow some overlap during the long extra exposure given to the sky. Low contrast was used because this was the easiest way to put density into the sky without any noticeable overlap. I gave the picture a basic exposure of 70 seconds at f8 using grade 4, giving the first figure 30 seconds less exposure, the second figure 20 seconds less exposure, and the foreground snow and rocky outcrop 10 seconds less exposure. The sky was given 35 seconds extra exposure using grade 0.

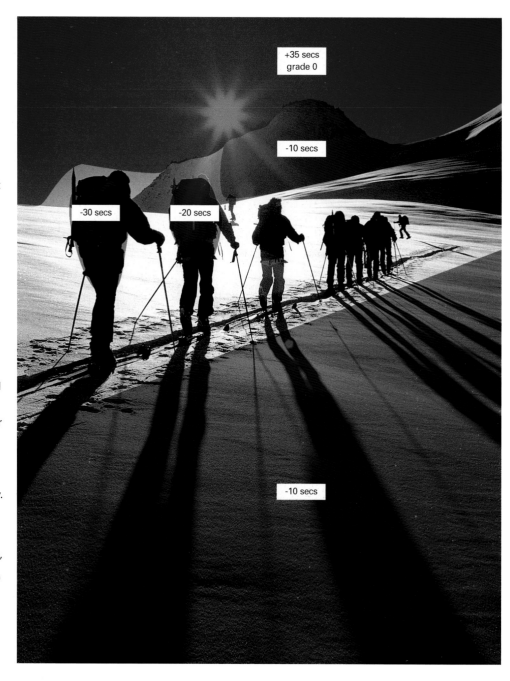

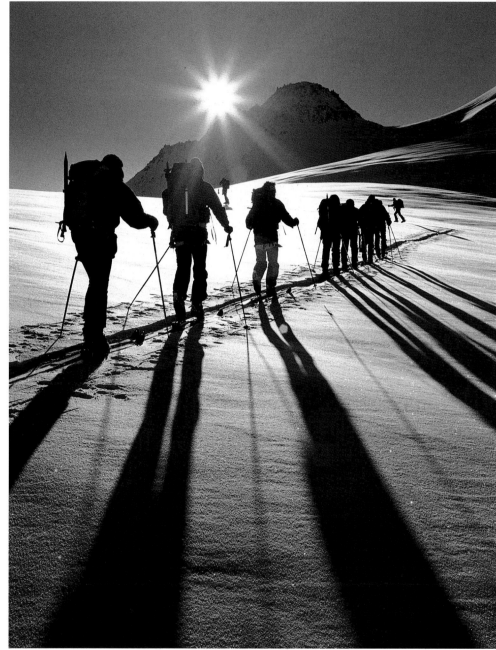

Dave Butcher

+10 secs

Farmers
Reducer

Sid Reynolds

Print: Becalmed

I was immediately attracted by the grouping of these Thames barges which created an attractive composition. It is very unusual to see so many of these barges together. It was this factor combined with the wonderful lighting that produced the image I wanted. The shot was taken at the annual barge race on the River Stour, near Ipswich.

Technical Details

6 x 6cm twin lens reflex camera; 1/300 second at f5.6 with a x 2 yellow filter. Ilford FP4 ISO 125 developed in Unitol.

Print Details

This exhibition print was made on Agfa Record Rapid fibre-based paper, grade 4 and then developed in Ilford PQ Universal. My overall exposure was for 1 1/4 minutes. I burned in the top left-hand corner of the image for 10 seconds to help balance the sky in the print and I used Farmer's Reducer in the centre of the sea to lighten this area and to enhance the sparkling effect of light on the water.

Tip: Farmer's Reducer is a chemical solution which bleaches away the silver image. It can be used to brighten small areas of a print, or the whole print can be immersed in the solution to rescue a muddy or overexposed image. After the reducer has been used the whole print must be fixed again.

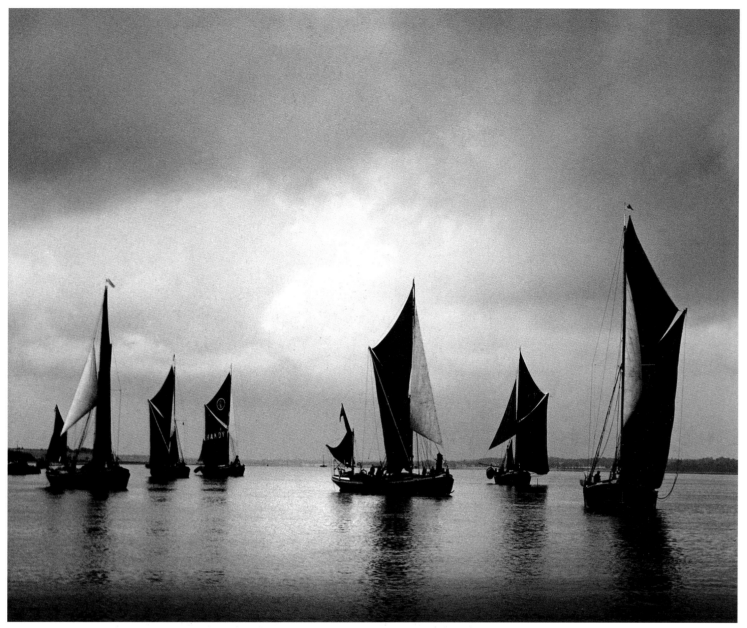

Sid Reynolds

+45 secs

+10 secs

+30 secs

Sid Reynolds

Print: Sun, Fog and Smoke

At first light the drifters leaving for the fishing grounds give an air of tranquillity enhanced by the calmness of the sea. It was this mood that I wanted to capture here. I set my shot up from the fish market at Lowestoft and waited for the right elements to come together.

Technical Details

6 x 6cm twin lens reflex camera; 1/300 second at f5.6. Ilford FP4 developed in Microdol. No filter was used because I didn't want to destroy the foggy background.

Print Details

This exhibition print was made on Agfa Record Rapid, grade 3. This particular fibre-based paper has a wonderful quality and feel about it. I gave this print an overall exposure of 1 minute, but owing to the intense amount of light on the right-hand side, considerable burning in was required to balance tones: 45 seconds in the top right-hand corner, 10 seconds to the right of the boat and 30 seconds in the water.

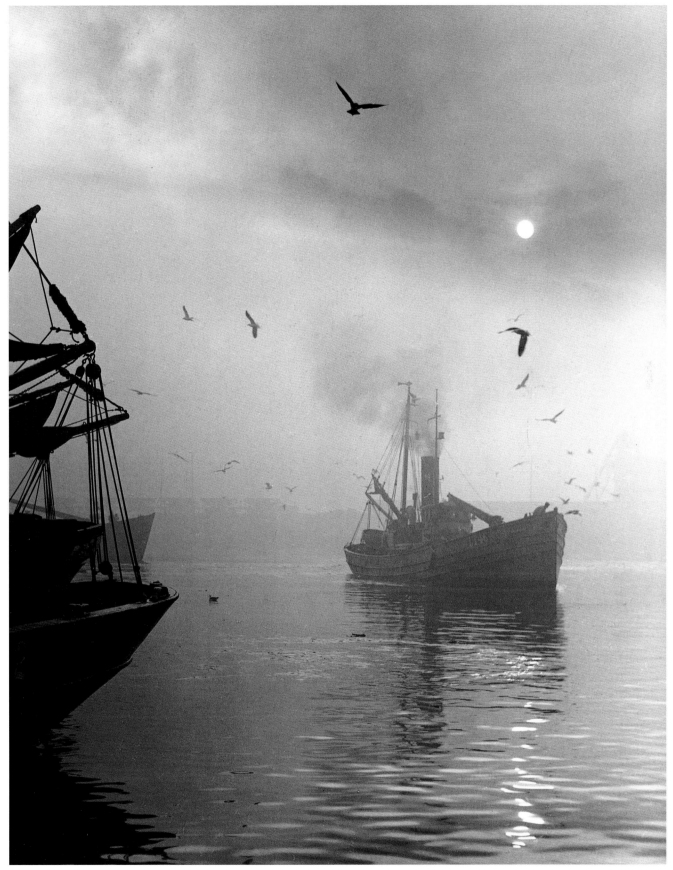

Sid Reynolds

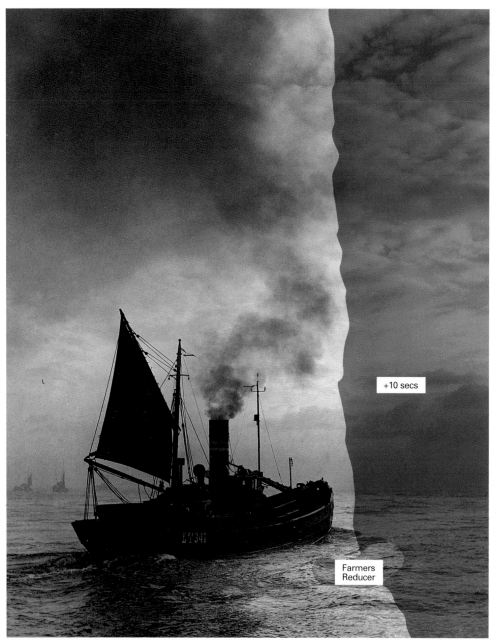

+10 secs

Farmers
Reducer

Sid Reynolds

Print: Old Smoky

My aim was to capture the mood and atmosphere of this steam drifter on its way to the fishing grounds. This was shot from the South Pier at Lowestoft and again it was taken following an early morning start. At this time of day, photographs often have a unique air about them; the real satisfaction comes from the feeling that you have successfully captured this.

Technical Details

6 x 6cm twin lens reflex camera; 1/300 second at f5.6 with a x 2 yellow filter. Ilford FP4 developed in Microdol.

Print Details

This exhibition print was made on Agfa Record Rapid fibre-based paper using grade 3 and developed in Ilford PQ Universal. The first print showed that the photograph was pretty much as I had envisaged it, except that the right-hand side had lost some of the original detail. I gave the final print an overall exposure of 1 1/2 minutes, giving the area on the right an additional 10 seconds exposure to bring back some of the lost detail. Then I used a weak solution of Farmer's Reducer to enhance the effect of light on the water near the stern.

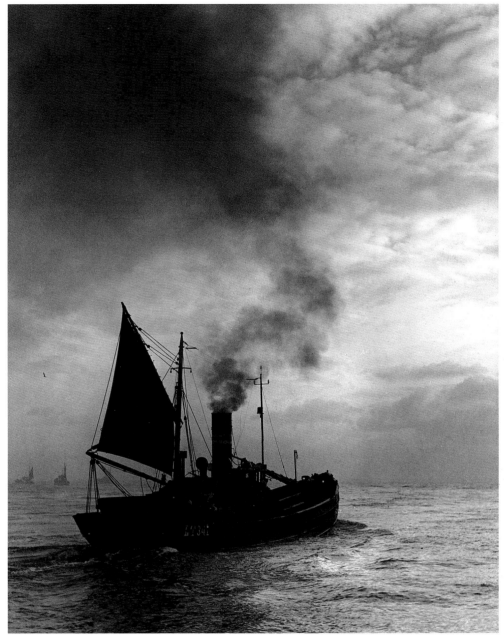

Sid Reynolds

Tip: Selenium toner can be used at various dilutions on a washed but still-wet print or a finished print that has been re-wetted. Its effect can range from making the print more archivally sound with little effect on the image to a subtle or even greater intensification caused by slightly increasing the contrast and density within the blacks of the print and occasionally altering the highlights. Selenium toner must be used with extreme care as it is a toxic substance which can be absorbed through the skin.

Michael Milton

Print: Observer Building, Battersea, London

I liked the Egyptian-style frontage of this building which, despite its classical appearance, dates from no longer ago than the 1980s and I set up a position that enabled me to incorporate the gasometer in the view. This gave me an interesting mixture of old and new, and then I worked out my exposure by taking a reading from the overall scene.

Technical Detail

35mm SLR camera; 28mm lens; 1/125 second at f16. Kodak Tri-X ISO 400 developed in Ilford Ilfosol-S at a dilution of 1 to 9 for 10 1/2 minutes at 20 degrees C.

Print Details

Agfa's Record Rapid fibre-based paper grade 2 developed for 2 minutes in Agfa Neutol diluted at 1 to 4. The enlarger is a condenser type. The overall exposure was for 12 seconds at f8 with 6 seconds burning in the white frontage. The finished print was selenium-toned at a dilution of 1 to 19 for 15 minutes.

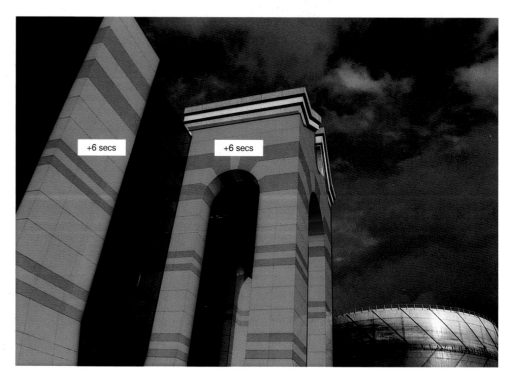

+6 secs +6 secs

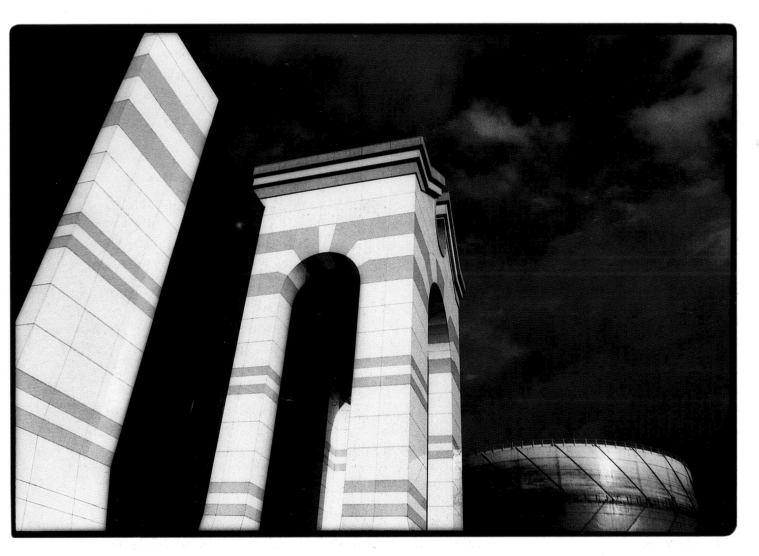

Michael Milton

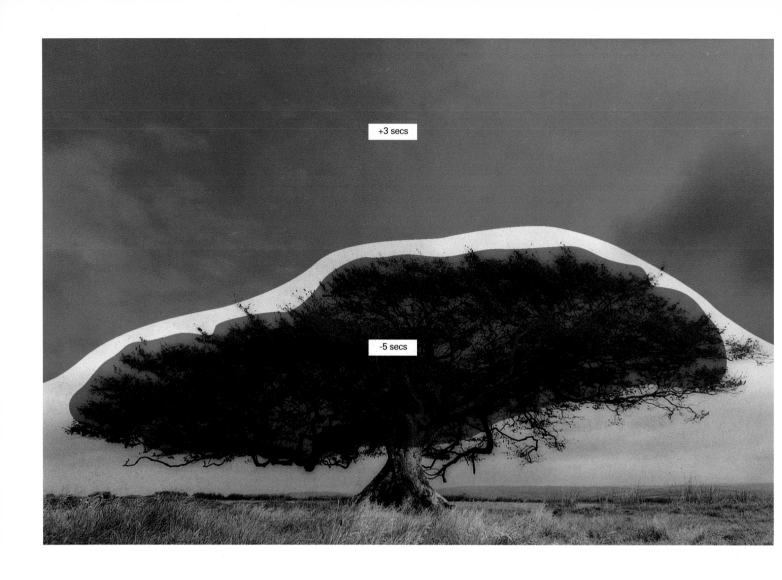

Michael Milton

Michael Milton

Print: Lone Tree

What amazed me when viewing this tree was its width compared to its overall height. With no scale it takes on a bonsai quality. This picture was taken on a slightly overcast day and I took a meter reading from the ground, sky and the palm of my hand to obtain my exposure.

Technical Details

35mm SLR camera; 28mm lens; 1/60 second at f16 with a yellow filter. Kodak Tri-X ISO 400 developed in Ilford Ilfosol-S at a dilution of 1 to 9 for 10 1/2 minutes.

Print Details

Agfa's Record Rapid fibre-based paper grade 3 developed for 2 minutes in Agfa Neutol diluted at 1 to 4. The enlarger is a condenser type. The overall exposure was for 12 seconds at f8 with 3 seconds burning in the sky. To retain detail there, I dodged the branches of the trees for 5 seconds with a dodging tool. The finished print was selenium-toned at a dilution of 1 to 19 for 15 minutes. This was to achieve archival permanence.

Michael Milton

Print: Saunton Beach, UK

Walking along the beach at low tide I was struck by the reflections, atmosphere and quality of light. I took meter readings from the ground, sky and the palm of my hand, this time in shadow.

Technical Details

35mm SLR camera; 28mm lens; 1/250 second at f16. Kodak Tri-X ISO 400 developed in Ilford Ilfosol-S at a dilution of 1 to 9 for 10 1/2 minutes.

Print Details

Agfa's Record Rapid fibre-based paper grade 3 developed for 2 minutes in Agfa Neutol diluted at 1 to 4. The enlarger is a condenser type. The overall exposure was for 12 seconds at f8 with 3 seconds burning in the right-hand side of the image where the light had bleached out some of the detail. The finished print was selenium-toned at a dilution of 1 to 19 for 15 minutes. This was to achieve archival permanence.

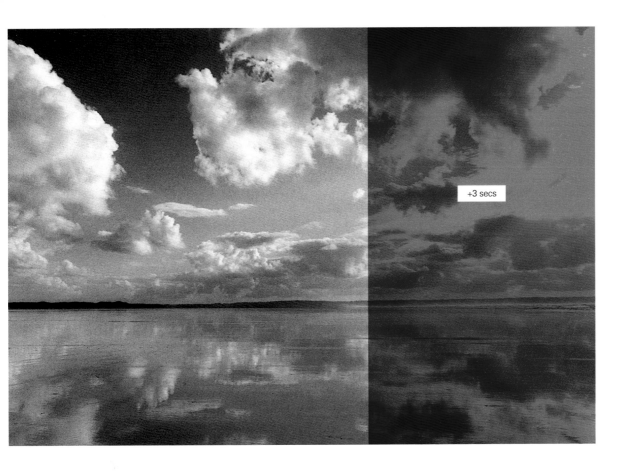

+3 secs

Michael Milton

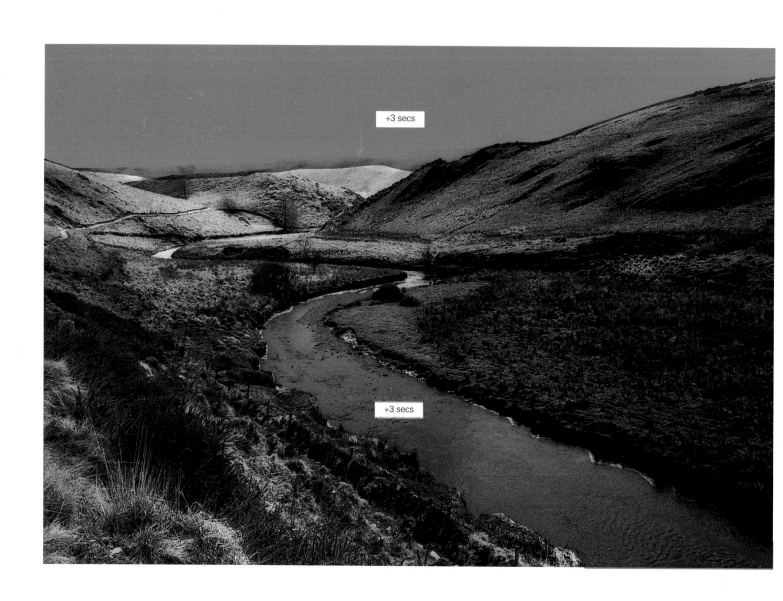

Michael Milton

Print: Exmoor Moorland

I liked the way the stream in this particular valley draws the eye into the picture and on towards the mist on the distant hills. My meter reading was taken from the ground and I then opened up by one stop from this reading to make the exposure.

Technical Details

35mm SLR camera; 28mm lens; 1/60 second at f16. Kodak Tri-X ISO 400 developed in Ilford Ilfosol-S at a dilution of 1 to 9 for 10 1/2 minutes.

Print Details

Agfa's Record Rapid fibre-based paper grade 3 developed for 2 minutes in Agfa Neutol diluted at 1 to 4. The enlarger is a condenser type. The overall exposure was for 14 seconds at f8 with 3 seconds burning in the stream and an additional 3 seconds for the sky. The finished print was selenium-toned at a dilution of 1 to 19 for 15 minutes.

Michael Milton

Section 7
Finishing Touches

All the hard work you put in to produce a print can all be undone if you don't take the necessary care over the finishing touches, perhaps some light retouching to remove dust marks or a cosmetic change such as adding a border. Good presentation is also important to the success of your pictures, and you'll be amply repaid for all the time and effort you spend on this sometimes-neglected area.

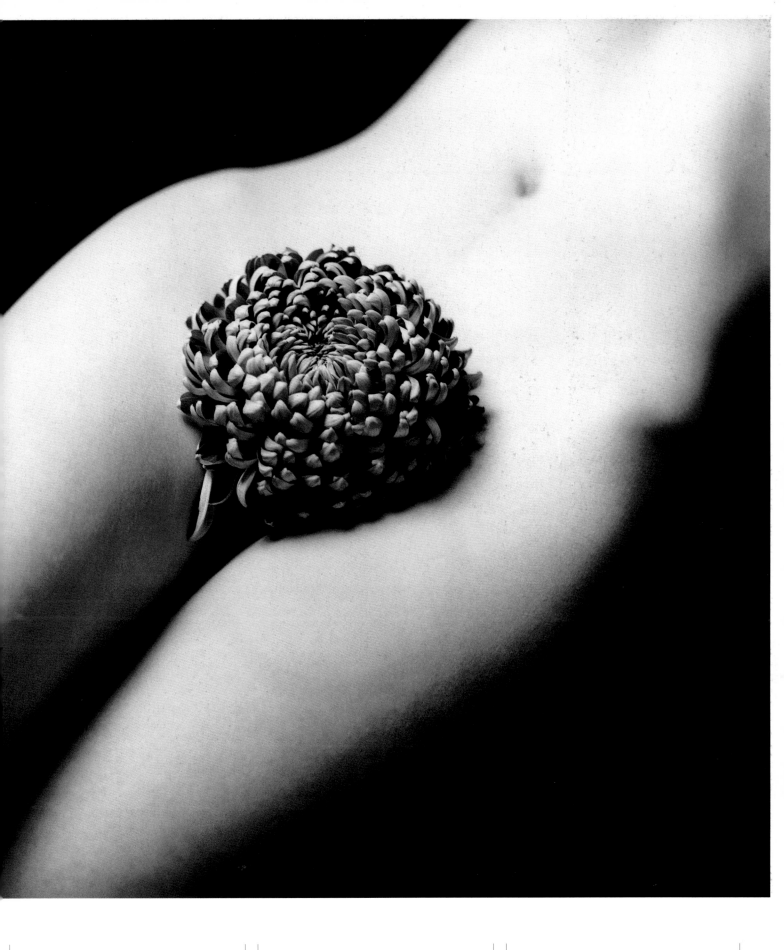

01. Creating Borders

Black borders – the easy way

One of the most popular choices for a print border, other than leaving the edges of the paper white, is to add a fine black line around the image. The simplest method of doing this is to draw the border in with a marker pen, making sure that the line around the image is neat and precise. This method is the only way a black border can be added to a finished print. Although this may sound like a bit of a cheat, this is frequently done by many professionals and can give a very effective finish.

Black borders – using the negative carrier

It is possible to add a black border at the printing stage by using the negative carrier. By far the simplest method is to use a negative carrier with a window that is larger than the format of the negative. This is simple when using 35mm film – by stepping up to a 6 x 6 carrier you can print the clear emulsion around the edge of the negative which will give a clean black line that can be set to the width you want through a simple adjustment of the masking frame. With medium-format negatives you will need to use a universal carrier with a large window which is intended to be masked down to the chosen format using the blades incorporated in the carrier itself. With careful adjustment here you can achieve a good-quality border by not masking down fully and printing some of the negative rebate.

Black borders – filing the negative carrier

This method leaves a relaxed, less formal border which is a popular look but less than straightforward to achieve. It involves filing back the negative window within the carrier very carefully to give an uneven black edging by allowing some of the clear emulsion of the negative to be exposed on to the paper. This method sounds a little severe but it does give a very effective finish. The main pitfalls are that the filing must be done with extreme caution with just one tiny bit filed away at a time to avoid an overwhelming effect that will wreck a perfectly good negative carrier. It is important to rub the edges with a fine emery paper to smooth out any sharp edges that may scratch the negative.

Having gone through all this, I now prefer to print my images full frame (without any cropping) and leave a large white border (2–3 inches) around the edge of the print. This suits me just fine and looks very neat in a portfolio. A heavy, thick black border is in any case less than complimentary to the image, so even if you do go for black – stick to relatively fine lines.

Spotting a Print

Having to retouch dust marks, hairs or scratches on a print is tedious to say the least, unless you happen to enjoy that kind of thing. I therefore go to great lengths to ensure my negatives are as clean as possible but now and again spotting is the only solution. The whole procedure can be made easier by using a good spotting kit. The Spotone kit is the best, and the finest brush you can see to use. The inks come in variations of black so that precise matching to the print is relatively easy. Using a white saucer, it is possible to dilute a brushful of the ink with a tiny amount of water if needed. The white saucer allows you to judge the colour and density of the ink. It is best to wear cotton gloves or work with a piece of soft material under your hand, helping to prevent further marks. The brush must have an absolute minimum of ink on it and successful retouching can only be done by building an area up to the required density by using the brush to create little dots that gradually build to form a solid tone. Test a little of the ink first on a spare piece of developed paper that matches the one to be retouched.

For black marks you can buy a Spotoff kit. Basically a bleach, this must be worked in the same way as spotting ink. Then, using inks, it may be necessary to build back the desired tone. Never attempt to scratch away a black mark otherwise you will be back in the darkroom redoing the print as this will show up because of the damage to the print emulsion.

A negative carrier with a window that is larger than the negative will create a black border.

A good quality spotting kit is essential.

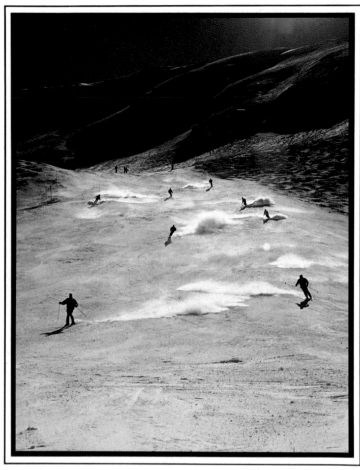

Dave Butcher

Print: Kicking up the Powder, St. Christoph, Austria

Dave Butcher took this shot towards the end of a very cold day. The low temperature kept the covering of very light powdered snow on the runs all day. Dave positioned himself in the middle of a run and metered off the snow in shadow on his right, locked the exposure and recomposed the image. He waited until he had good separation of the skiers and plumes of powder kicked up against the light before taking the shot.

Technical Details

6 x 6cm Rangefinder camera with a 50mm lens and yellow filter; 1/250 second at f22. Ilford FP4+ developed in Ilfosol-S diluted 1 to 9 for 6 minutes.

Print Details

Ilford Multigrade IV resin-coated paper in a glossy finish. The print was developed in Multigrade developer at a dilution of 1 to 9 for 60 seconds. Basic exposure was 35 seconds at f8, grade 2 1/2. The clean-cut double black borders look particularly neat and can be achieved by using a black marker; representing a striking contrast to the somewhat unfinished but relaxed look created by the filing-back method.

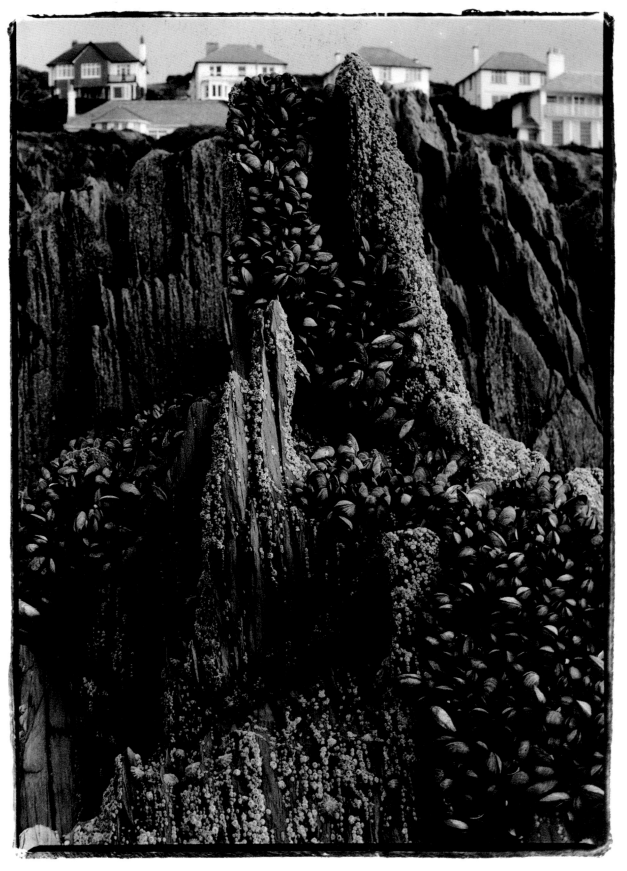

Julien Busselle

Print: Mussels

This picture was taken as I turned to leave the beach after a windswept session photographing the surf as it came rolling in. The relationship between the mussels and their cramped housing and the human dwellings above amused me.

Technical Details

6 x 4.5cm SLR camera with a 45mm lens; 1/30 second at f8. Ilford XP2 developed in C-41 chemicals.

Print Details

The print was made on Ilford Multigrade IV resin-coated paper. The diffuser enlarger that I used was fitted with a variable-contrast head. I exposed the print for 15 seconds at f8 and used the filters to give me a contrast of grade 4. The border was created by using a filed-back negative carrier as described earlier.

02. Toning

Toning a print adds another dimension to a black-and-white image. The effects can be subtle or dramatic and toning can – and should – be done in good light, giving you a change from normal darkroom work. Listed below are some popular toners and a brief explanation of their effects – the names can be a little misleading. A more thorough approach to toning will be covered in volume 2 of this series. Toning should take place after the print has been thoroughly fixed and washed; underwashing can lead to the toned print having a stained appearance. Mix all toners up according to the manufacturer's instructions and log times so that the effect should be repeatable though be aware that the toning process can be unpredictable even when you're following directions to the letter. Fibre-based paper is often preferred for toning but resin-coated papers can perform well too. Experimentation is the best way to learn here.

Three basic toners
The three toners here will also have an archival effect on the print. The silver grains of the image are replaced or in some cases surrounded by a more stable metal, making the image more permanent.

Sepia
This is supplied as a two-bath toner consisting of a bleach bath followed by the toner itself. Two types are available – sulphide based which has a rotten-egg smell and produces a deep brown image, and thiocarbamide based which is odourless and produces a yellow through to brown image. An alternative to this is Agfa Viradon which produces a deep chocolate-brown image and does not use a bleach.

Gold
This tends to give a bluish hue rather than the assumed colour effect – the name is from the gold metal that is deposited on to the silver salts. When used on a sepia-toned print, however, this toner can produce a range of colours from an orange gold to a rusty red.

Selenium
The effect of this toner will vary according to the dilution used and paper type. With chloro-bromide papers, such as Agfa's Record Rapid, the colour shift will be towards a purple brown if left long enough. Selenium has an intensifying effect and will 'split tone' – the shadows alter in colour whilst the highlights remain unaffected. This toner is toxic so take sensible precautions.

Print: Marie dei Medici's Waterworks, Luxembourg Gardens, Paris

Taken in a cold November light, this shot was taken to illustrate a book on Impressionism. The intention was to produce an image that had no reference to the present day. The Luxembourg Gardens are perhaps my favourite in Paris and this was a good excuse to make another visit.

Technical Details

35mm SLR camera with a 28–70mm lens; 1/8 second at f22. Ilford XP2 developed in C-41 chemicals.

Print Details

Ilford Multigrade IV resin-coated paper in a pearl finish. The print was developed in Multigrade developer at a dilution of 1 to 9 for 60 seconds. Basic exposure was 20 seconds at f8, grade 4. The print was then sepia toned to produce the required effect, giving a rather vintage look.

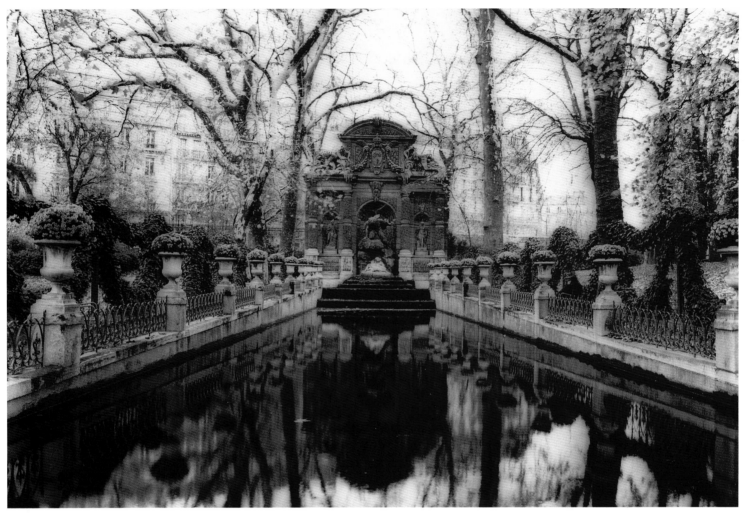

Julien Busselle

Tip: Always tone a print with an untoned print alongside and look away frequently as this will help you to see the more subtle changes that take place.

03. Storage and Presentation

Whilst exhibition work is visually presented in a bevel-cut mount, surrounded by a nice frame and displayed in ideal light conditions, the humble portfolio is often given far less priority. The fact that most photographer's portfolio work is of exhibition quality means that the degree of care in presentation should be to the same standard. Whilst many professionals go to great lengths to achieve a well-presented portfolio, the casual photographer is happy to glue prints on to a black page and place this in a less than complementary plastic sleeve.

As far as storage is concerned, the opinion that any box is adequate is also somewhat misguided. Prints that have been lovingly processed to archival standards need to be stored correctly, as do negatives. A photographer's work is based upon capturing a scene at a particular point in time. As this is unlikely to be repeated it is important for that work to last its expected life span.

Storing negatives and prints
Black-and-white negatives and prints are under attack from airborne contamination such as fumes and, in extreme circumstances from damp spores. Chemical action in the form of acids from inadequate storage and presentation materials also contribute to early deterioration. Don't forget the obvious precautions such as making sure that you don't subject your prints to lengthy exposure to strong light.

The simplest method of storage for a print is to place it in an enclosure made from an archival-quality material. This can range from a simple sheet of archival paper to a polyester print sleeve and a proper print storage box. Negatives are best stored in a polyester negative bag and a box or binder that has an inert acid-free barrier. Many retailers now offer a range of sleeves and boxes designed for archival storage. If you wish to have prints and negatives that can be appreciated in the future for their quality, you should ideally aim for this standard from the start, even if at this stage these methods seem over the top.

You should also be careful where you place your work in its enclosure. The bottom line is that no matter how carefully you choose storage materials, you must take care with suitable storage conditions – not too hot or cold, nor too damp or dry. Attics and garages may be a popular choice, but they are generally the worst places.

Portfolios
The most common way of presenting a print in a portfolio is by securing it to a sheet of card or paper and placing it in a case that is essentially a huge, attractive ring binder. Although a good standard of presentation can be achieved, in the long term it would be better to consider something a little more viewer-friendly. I would suggest that for black-and-white prints you take a look at the print viewing box.

This method of presentation allows the prints to be displayed unbound, making last-minute picture changes easy. The box opens out to two trays which lie perfectly flat; the viewed prints are simply slid from one tray to the other. The two methods of presenting prints in a viewing box are listed below. If you choose the archival sleeve method of presentation it would also be wise to ensure the box is to the same standard.

Encapsulation (lamination) is popular and this does give a very attractive and durable means of presenting the print – ideal if your prints do a good deal of travelling and go through many hands. Encapsulated prints are normally displayed loose in a print viewing box. A drawback is that once the encapsulation becomes scratched or worn, the print also becomes redundant. It is also not suitable for reproduction.

In my opinion, the answer lies with presenting the prints in a specially designed polyester sleeve together with the viewing box. The sleeve is not only archivally sound but the level of clarity is far superior to many other transparent sleeves, so the print looks good and yet it can be removed for reproduction. Should the sleeve become marked it is simply replaced. Perhaps the sleeve style of presentation is a little more casual and less robust than encapsulation but it does offer benefits, especially if your portfolio prints are to exhibition standard and you want access to them.

The viewing box style of portfolio is, in my opinion, the best for black-and-white prints. I prefer to use mine with the prints in polyester sleeves rather than encapsulating them, although both are popular ways of presenting the print.

Glossary

Aperture: Variable-sized hole used to control the intensity of light passing through a lens on to the film or paper. Camera lenses are calibrated using f numbers such as f2.8, f4 and f5.6, each reducing the image brightness by 50% but enlarging lenses can be simply marked numerically i.e. 1, 2, 4 and so on, in steps of 50% brightness reduction.

Bleaching: The reduction in density of an exposed and processed print by application of a dilute solution of Potassium Ferricyanide. It can also be used to remove black spots and is often used as a prelude to toning.

Bromide Paper: A printing paper which gives a blue-black image when the appropriate developer is used.

Burning in: A printing technique in which additional exposure is given to selected parts of the image to create a darker tone.

C-41 Chemistry: The standard colour negative chemistry which is also used to develop black-and-white chromogenic film.

Chloro-bromide Paper: A printing paper that gives a warm, brown-black image when used with the appropriate developer.

Chromogenic Film: Film, such as Ilford XP2 Super, which uses dyes to create a monochrome image instead of the silver-based emulsion used in conventional black-and-white films.

Contact Print: A print made by placing a negative directly on to the printing paper, held flat by glass during exposure to produce a same-size image. This is the normal way of making reference prints from a complete roll of film.

Contrast: The difference in brightness between the lightest and darkest areas of a scene or the lightest and darkest tones of a negative or print.

Definition: The ability of a lens or a film to record fine detail in sharp focus.

Depth of Field: The distance in front and behind the point at which a lens is focused which will be rendered acceptably sharp. It increases when the aperture is made smaller and extends about two-thirds behind the point of focus and one-third in front. The depth of field becomes smaller when the lens is focused at close distances. A scale indicating depth of field for each aperture is marked on most lens mounts and it can also be judged visually on SLR cameras which have a depth of field preview button.

Depth of Focus: The term used to describe the range of sharp focus at the film plane and which increases when the aperture is reduced. Setting a small aperture on the enlarging lens will help to ensure the image will be in sharp focus when the negative is not completely flat in the carrier or focusing is not 100% accurate.

Dodging: A printing technique in which a selected area of the image is shielded during the exposure to make it lighter in tone.

Dry Mounting: A method of mounting photographic prints on to card mounts using a bonding tissue and the application of heat and pressure.

DX Coding: A system whereby most APS, 35mm and some medium-format cameras read the film speed from a bar code printed on the cassette or roll film and sets it automatically.

Emulsion: The light-sensitive coating on a film or paper which forms the image after exposure and development.

Evaluative Metering: An exposure meter setting in which brightness levels are measured from various segments of the image and the results used to compute an average. It's designed to reduce the risk of under or overexposing any subject with an abnormal tonal range.

Exposure Compensation: A setting which can be used to give less or more exposure when using the camera's auto-exposure system for subjects which have an abnormal tonal range. Usually adjustable in one-third of a stop increments.

Farmer's Reducer: A chemical solution that bleaches away the silver image. It can be used to brighten small areas of a print or the whole print can be immersed in the solution to rescue a muddy or overexposed image. After the reducer has been used, the whole print must be fixed again and washed.

Fibre-based Paper: Printing paper in which the emulsion is coated on to paper made from natural wood fibre. It requires thorough fixing and washing to prevent image deterioration but produces a superior result to resin-coated paper. It's available in a variety of weights and surface textures.

Filter Factor: An indication of the amount the exposure needs to be increased to allow for the use of a filter: x 2 filter needs one stop extra exposure; x 3 one-and-a-half stops more; x 4 two stops more, and so on.

Flashing: The technique of giving a piece of printing paper a very brief exposure to ambient light before exposing the negative in order to reduce the image contrast.

Focus Finder: A high-powered, microscope-style magnifier that is used on the enlarger baseboard allowing a negative to be focused with great accuracy on the film grain, even when the enlarging lens is stopped down.

Fogging: The effect of exposing film or paper to unsafe ambient light, often caused by a light leak in a darkroom or a safelight which is too bright or has the wrong screen.